SHREWSBURY
THEN & NOW
IN COLOUR

David Trumper

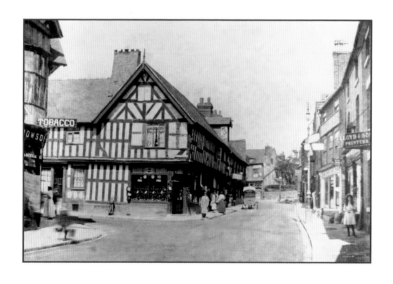

The History Press

For My Daughter Vicki.
With Love.

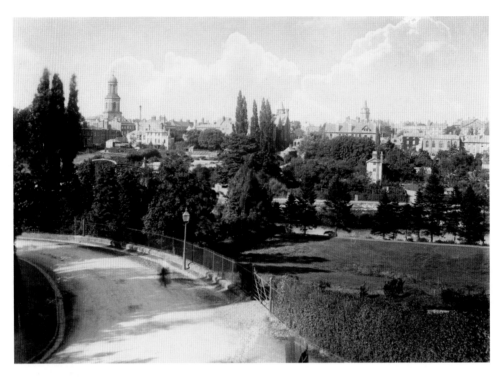

The approach road to the Kingsland Bridge from Canonbury, *c.* 1890.

Title page photograph: Frankwell, *c.* 1910.

First published in 2012

The History Press
The Mill, Brimscombe Port
Stroud, Gloucestershire, GL5 2QG
www.thehistorypress.co.uk

British Library Cataloguing in Publication Data.
A catalogue record for this book is available from the British Library.

ISBN 978 0 7524 6405 3

Typesetting and origination by The History Press
Printed in India.

CONTENTS

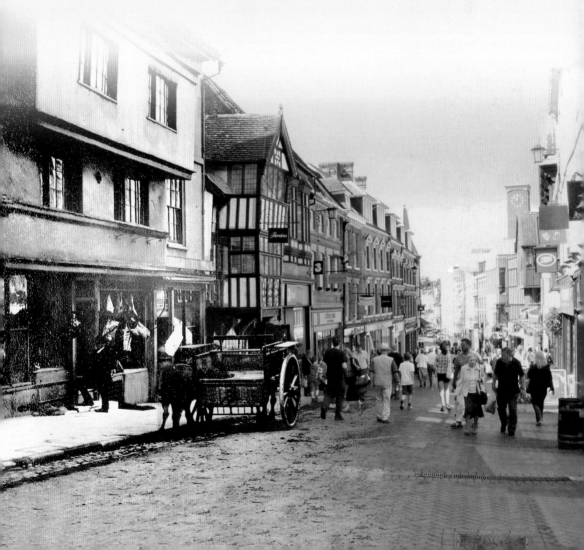

INTRODUCTION

Shrewsbury, built on two hills in the defensive loop of the River Severn, has a history of over a thousand years. First written evidence of a settlement is in 901AD when the town was known as Scrobbesbyrig, meaning the fort in the scrub. On 11 November 1189 King Richard I granted the burgesses of Shrewsbury a charter and since that date the history of the town has been well documented.

The history of the town can also be studied through its buildings. Beneath the ground and under several buildings in the centre of Shrewsbury there are Saxon remains. The embankment on which Laura's Tower is built in the castle grounds is possibly the site of the original motte and bailey castle built before the Norman Conquest to defend the only land route into town. Saxon remains lie beneath the foundations of the four medieval churches in the town centre and although three have been rebuilt, St Mary's, erected at the highest point of the town with its 222ft tower and spire, stands as a monument to several generations of builders.

By the fourteenth century Shrewsbury was a centre of the Welsh wool trade, which brought a great deal of prosperity to the town. In tax returns it was ranked the richest town in the northern Welsh Marches and in 1334 it was classed as the seventh most affluent town in England. Over the next three centuries the wool trade was regulated by the Drapers' Guild whose members became some of the wealthiest citizens of the town enabling them to build the fine timber-framed houses that Shrewsbury is famous for.

In the second half of the seventeenth century Shrewsbury settled into the role of regional capital and the centre of social and economic life. This role was developed during the eighteenth century with the town hosting a variety of social functions and supplying a large hinterland with goods and other services. A number of the county's leading families had homes in Shrewsbury and many of the elegant Regency and Georgian townhouses were built at this time on the south-west of the town around Belmont, Swan Hill and St John's Hill. The main social events revolved around the Lion Hotel, which by the end of the eighteenth century was a leading coaching house on a direct route from London to Holyhead.

Owing to the confined space inside the loop of the river, all the large industrial enterprises of the late eighteenth and early nineteenth centuries were developed in the suburbs. A woollen mill was erected in Carline Fields in 1790 and adapted for cotton spinning in 1803. A flax mill was opened in Ditherington in 1796 and two others in Castlefields and on Kingsland. William Hazeldine opened an iron foundry in Longden Coleham and George Burr opened a lead works not far away in Kingsland Road. The railway arrived in 1848 and a station was erected at the northern entrance to the town. Lines were built to the north of the town and across the river into Coleham where large engine sheds were sited. A second station was built in Abbey Foregate and a large carriage and wagon works was established close by. The nineteenth century saw many of the buildings within the loop of the river being adapted and modified to suit new purposes but several very fine timber-framed buildings were demolished from the corner of Mardol and Claremont Street in about 1866,

when the market hall site was being redeveloped. Several other timber-framed buildings were lost from Pride Hill in the 1880s when Richard Maddox extended his store out of High Street and onto the hill.

During the 1930s there was wholesale demolition in the Barker Street area with many ancient houses and slum dwellings being knocked down to make way for an inner ring road and car parking. Thankfully the Borough Surveyor Arthur Ward stepped in and saved Rowley's House and he was also instrumental in redeveloping the buildings on the south side of Barker Street and Belstone in a sympathetic manner. During the late 1950s and early '60s the Borough and County Councils embarked on a number of schemes and it was estimated that over fifty buildings of architectural interest in the town centre were bulldozed and replaced by concrete and glass. In February 1961 the *Chronicle* lamented, 'so much of Shrewsbury's heritage is being sold off,' but two months later recorded, 'Ancient buildings are holding up town's progress, protest councillors. Down with the old and on with the new.' Thankfully the Civic Society was formed in 1963 and has done a great deal to preserve Shrewsbury's rich heritage. Attitudes have also changed towards our ancient buildings and many people now love and treasure them, but there is no room for complacency as mistakes are still being made.

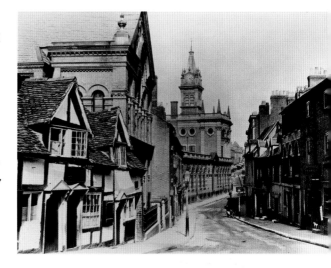

All the old photographs in this book were taken between 1880 and 1985. Wherever possible the photographer has tried to take the modern views from the same angle but owing to demolition, road realignment, undergrowth and health and safety issues this was not always possible. Therefore the modern views taken during the summer and winter of 2011/12 have been photographed from the nearest vantage point.

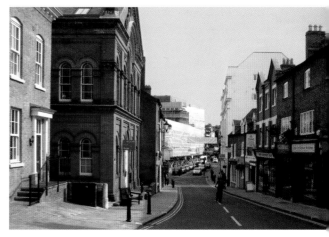

St John's Hill, *c.* 1890 and 2011. This street was once known as Swine Market or Pig Hill as the area was once used to sell pigs. The cottages on the left were demolished in about 1915. New town houses occupy the site of the old cottages nowadays.

THE STATION

SHREWSBURY RAILWAY STATION FORECOURT, *c.* 1901. Crowds gather to welcome home one of the volunteer companies that had been fighting in South Africa. The buildings directly in front of the photographer housed Thomas Wardle (a fish and game dealer) on the left, a tobacconists run by William Tudman in the centre and Allsop & Son brewers on the right. Behind Allsop's are the dining and refreshment rooms belonging to J.B. Davies on Castle Gates. He was also a baker and confectioner selling the celebrated Shrewsbury Cakes. Morris & Co. bought the business in 1919 and ran the café until 1959 and the confectionery shop until 1961. The large building to the right of Davies's is the Station Hotel, while the buildings below are occupied by E. Jones's temperance hotel and W. Holloway, who was listed as a practical watch & clockmaker, working jeweller and optician. Next was E. Healing, a confectioner who sold sweets, chocolate, a variety of biscuits and Barber's French Coffee; Mrs M.A. Rainford, a bookseller, stationer and newsagent and C. Bates a pork butcher.

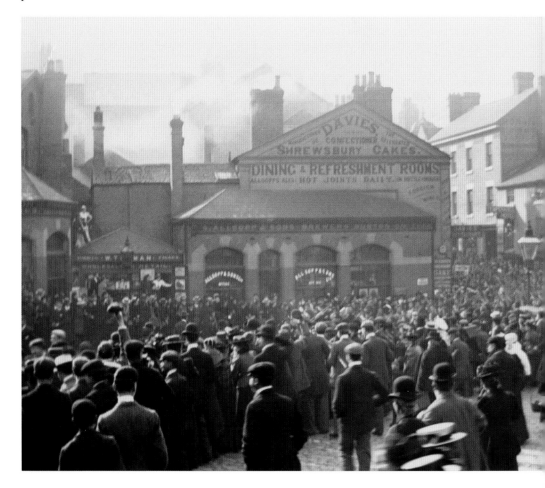

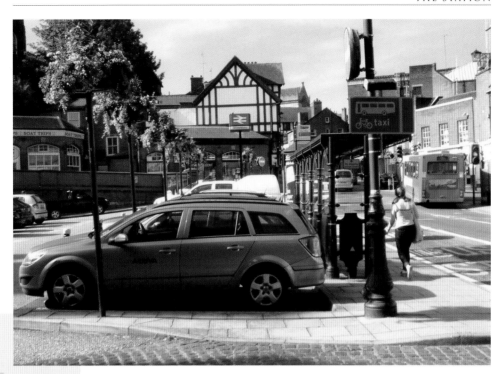

THIS MODERN VIEW was taken several feet lower down as the station forecourt was lowered by several feet shortly after the old view was taken. Tudman's shop has been removed while Wardle's is a local travel bureau advertising river cruises and Allsop's shop has become a newsagents. Davies's restaurant was also given a makeover when the roofline was altered and a timber effect added to fit in with the town's Tudor image. In the 1930s the buildings on the right were demolished to make way for the new Granada cinema complex, which was opened on 14 November 1934.

CASTLE GATES

CASTLE GATES, *c.* 1930. The shop on the left is on the corner of Meadow Place and belonged to James Baker & Sons Ltd, boot makers. To the right is the Station Hotel that belonged to the Northgate Brewery Co. and was first recorded in 1879. Just below is the sign of the Waverley Commercial Temperance Hotel run by Mrs E. Thomas. A larger temperance hotel known in the nineteenth century as the Welcome Coffee House was housed in the taller building right of centre. In about 1910 it changed its name to the Cleveland Hotel which advertised, 'First-Class Cyclist Accommodation'. The hotel closed in about 1930 when Richard Mansell moved his wholesale stationery warehouse there from Dogpole. Mr Mansell also had another shop on Wyle Cop.

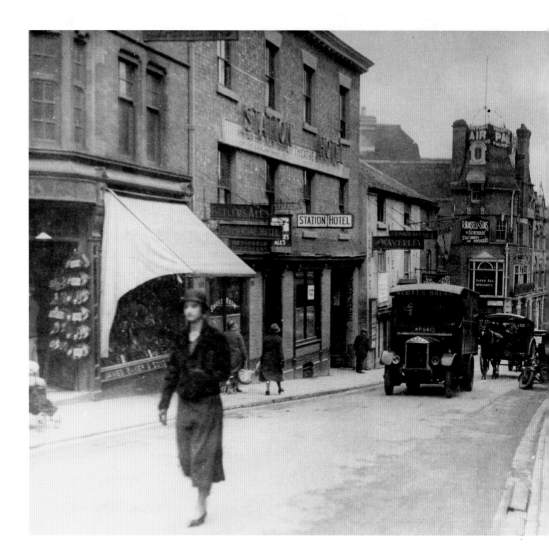

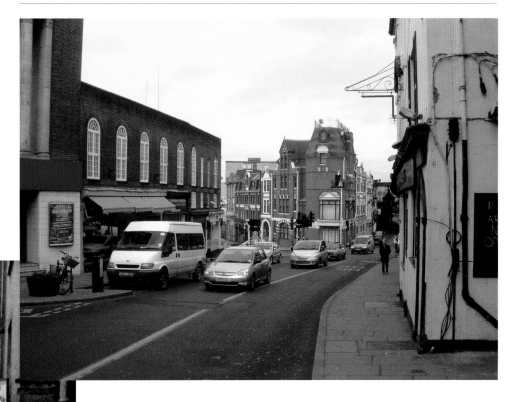

THE ROAD WAS widened when the old buildings on the left were demolished to make way for the Granada Cinema in 1934. The first film to be shown was *The Camels Are Coming* starring Jack Hulbert and Anna Lee. The cinema closed in April 1973 and a month later reopened as a bingo hall. With the demolition of the old buildings it can be seen that the old Welcome Hotel stands at the junction of Castle Foregate and Chester Street. In both views the Castle Vaults is in the first building on the right and just below the Bull Inn. At the beginning of the twentieth century this area was a drinkers' paradise as there were nine inns within 50 yards of each other.

CASTLE STREET

CASTLE STREET, *c.* 1930. Cattle being driven through the centre of town was a familiar sight in the first half of the twentieth century and the pedestrians here are taking little notice. The animals have probably been purchased at the cattle market on Smithfield Road, the main market day being on a Tuesday. The large house stands in the forecourt of the castle and was known as Castle House. It was occupied in 1896 by William Toye, a coal merchant who was Mayor of Shrewsbury in 1922. It was later occupied by Dr Alfred Frank Whitwell and then by Dr Aubrey Ireland. In his leisure time Dr Ireland was a dog breeder and judge at international dog shows.

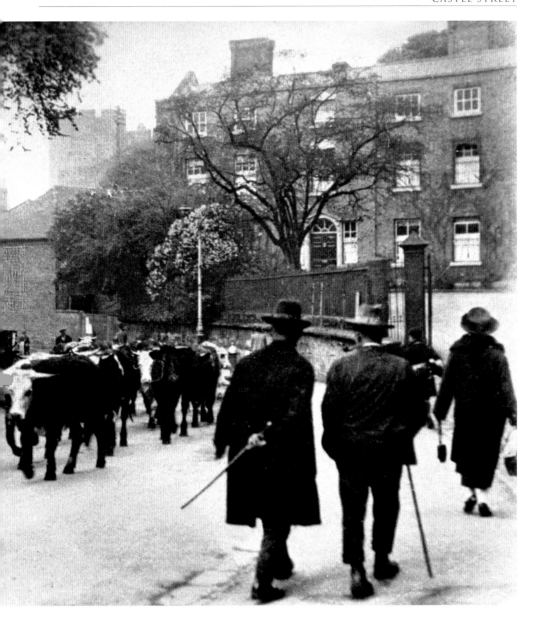

CASTLE HOUSE was demolished in the 1940s after Dr Ireland moved his home and surgery into Council House Court. The castle is now clearly visible and the forecourt has been lawned and landscaped. Two large field guns have stood on the site of the house since the castle was converted into a military museum which was opened in 1985. Across the road the large trees have been removed revealing part of the library. The building was formerly occupied by Shrewsbury School that was founded by Edward VI in 1552. They moved from this site to Kingsland in 1882.

CASTLE STREET
TOWARDS PRIDE HILL

CASTLE STREET, *c.* 1955. This view is looking towards Pride Hill. Note the absence of no parking signs and double yellow lines and that the street is open to two-way traffic. On the left Wildings offers wedding gifts, invitations and cake boxes. Businesses past the turning into Windsor Place include the District Bank, the Phoenix insurance office, Hammonds the fish and poultry dealer and the side elevation of Barclays Bank. To the right are the businesses of Melia's the grocers, Dorothy Perkins ladies' wear, John Cleland's shoe shop and the Raven Hotel. The Raven stood on that site for around 400 years and in the past the street was known as Raven Street. Just above are Whitfield's ladies' store, Newton's gentlemen's outfitters and Marks & Spencer.

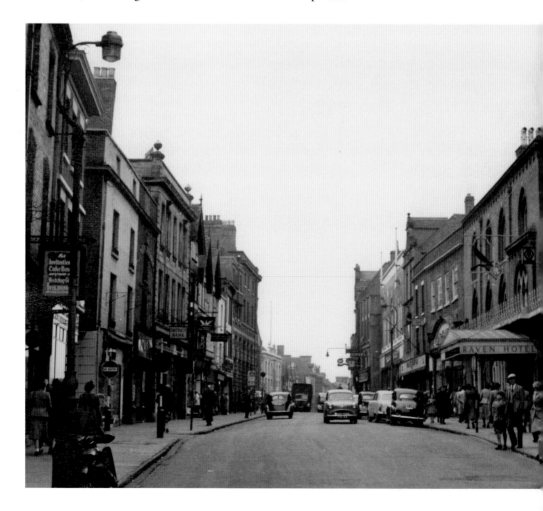

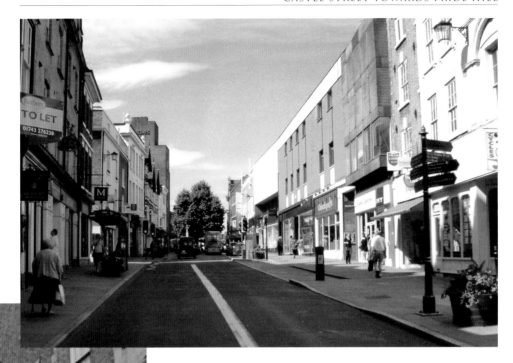

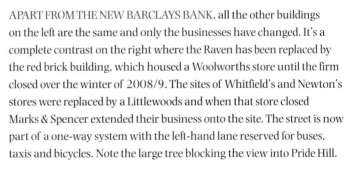

APART FROM THE NEW BARCLAYS BANK, all the other buildings
on the left are the same and only the businesses have changed. It's a
complete contrast on the right where the Raven has been replaced by
the red brick building, which housed a Woolworths store until the firm
closed over the winter of 2008/9. The sites of Whitfield's and Newton's
stores were replaced by a Littlewoods and when that store closed
Marks & Spencer extended their business onto the site. The street is now
part of a one-way system with the left-hand lane reserved for buses,
taxis and bicycles. Note the large tree blocking the view into Pride Hill.

13

PRIDE HILL

PRIDE HILL, *c.* 1959. The old Market Hall and St Chad's Church dominate the skyline of this view taken from the top of the new Barclays Bank. On the right is Morris's flagship store, modelled on Blickling Hall in Norfolk and opened in October 1927. Next door is the family firm of J.K. Overy, children's and gentlemen's outfitters, which was founded in Shoplatch in 1868 and moved to these premises in 1871. Just below is the original Woolworths store opened towards the end of the 1920s. The double-decker bus weaves its way up the hill even though parking restrictions are now in place. It's an S16 bus making its way to Bayston Hill.

THE NEW VIEW BELOW was taken from ground level outside the bank as health and safety rules do not allow the public onto the roof. Even so the contrast is startling. The traffic has disappeared as Pride Hill was pedestrianised over the winter of 1982/3 at a cost of £130,000. The old market hall was replaced in the 1960s by a concrete and brick structure with a tower that grew to a height of 180ft and was crowned with a 40ft aluminium spire. The large tree now obscures the buildings on the right.

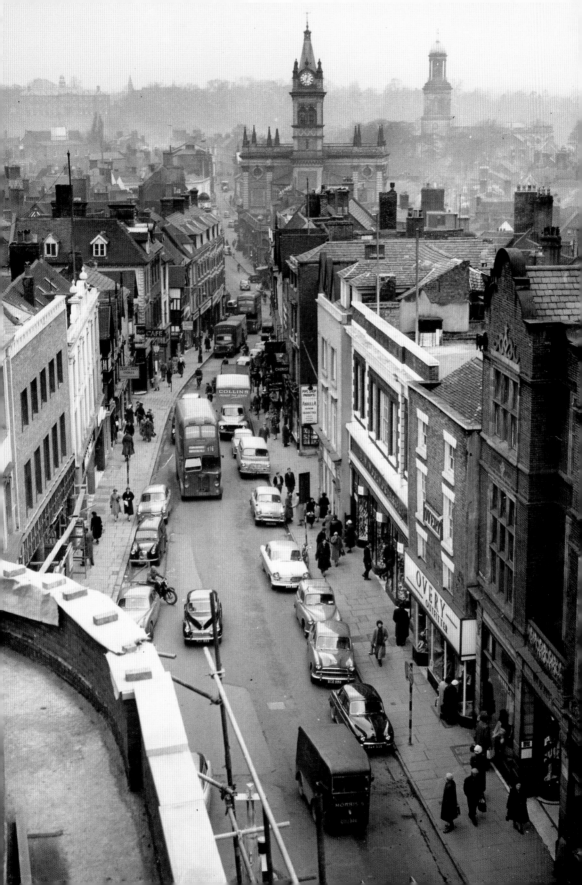

PRIDE HILL

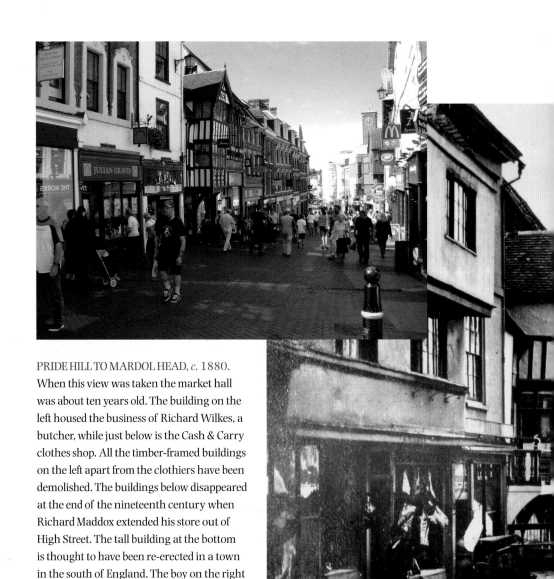

PRIDE HILL TO MARDOL HEAD, *c.* 1880. When this view was taken the market hall was about ten years old. The building on the left housed the business of Richard Wilkes, a butcher, while just below is the Cash & Carry clothes shop. All the timber-framed buildings on the left apart from the clothiers have been demolished. The buildings below disappeared at the end of the nineteenth century when Richard Maddox extended his store out of High Street. The tall building at the bottom is thought to have been re-erected in a town in the south of England. The boy on the right is standing outside George Mitchell's house furnishing and ironmongers shop. The shop was known as the 'Big Kettle' or the 'Little Dust Pan'.

THE CLOCK OF THE NEW MARKET HALL, built in the 1960s, is not as easily visible as the old one. The road was closed to traffic in 1982 and paved over. All the timber-framed buildings on the left have gone except for the one that houses Thornton's chocolate shop. The buildings at the bottom with the dormer windows once formed part of Maddox's department store, which was later taken over by Owen Owen before being closed and broken down into smaller units in 1993. On the right, Mitchell's shop has become part of McDonald's.

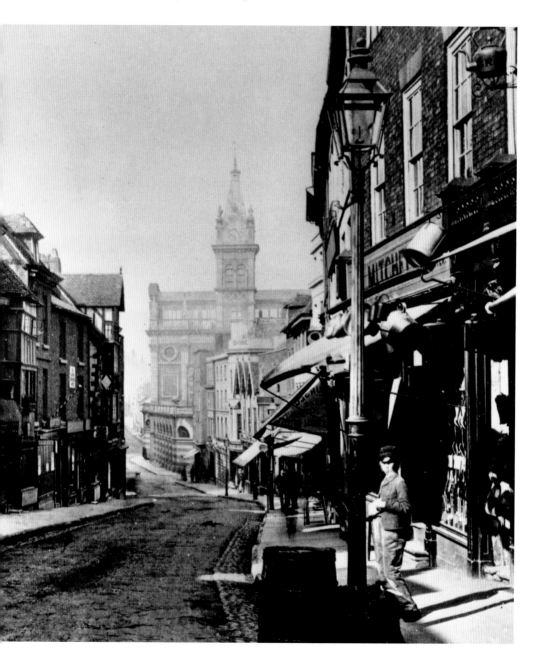

PRIDE HILL
TO MARDOL HEAD

PRIDE HILL TO MARDOL HEAD, *c.* 1955. The old market still dominates the skyline. On the right is Shuker & Son who were listed as ironmongers, hardware and builders' merchants. By 1914 they had opened their Central Garage in Roushill where they were agents for Humber, Sunbeam and Ford cars. Just below is a shoe shop belonging to W. & E. Turner and John Collier the 'Fifty Shilling Tailor'. In the timber-framed building next door is a branch of Lloyd's Bank. On the left is the department store founded by Richard Maddox. He opened his first shop in Gloucester House, Castle Street, in 1842 before moving to 26/7 High Street in 1862.

SHUKER'S SHOP HAS BEEN DEVELOPED into the entrance of the Pride Hill Centre, one of two large shopping malls built in the town in the 1980s. The building occupied by the shoe shop is still there but the buildings below were rebuilt in the 1960s. Lloyds Bank replaced their frontage in 1965 with concrete and glass. The jettied top storey is supposed to reflect and fit in with the town's rich heritage of timber-framed houses. The building received a Civic Trust Award in 1968!

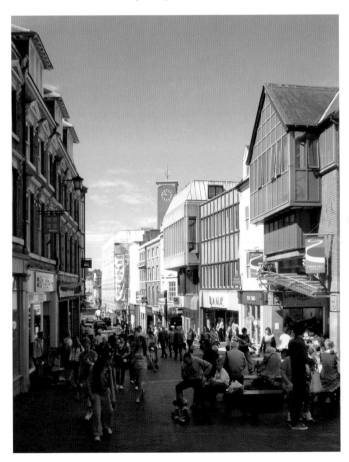

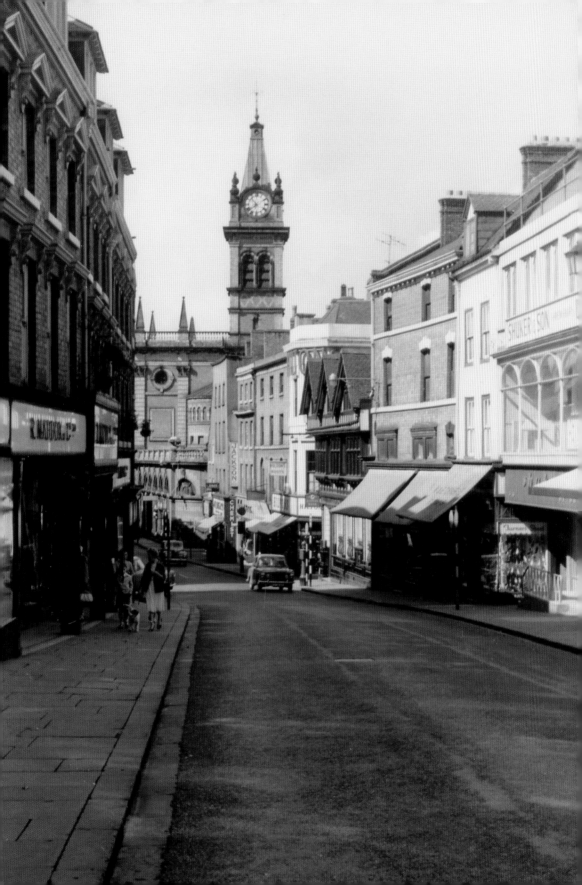

PRIDE HILL

PRIDE HILL, *c.* 1910. This street takes its name from the Pride family who owned a shop and property in the area in the thirteenth century, although the name did not come into common use until the nineteenth century. The left-hand side of the road has been called Corvisers' or Shoemakers' Row, while the right-hand side was known as Butchers' Row or the Shambles. The street has also been recorded as High Street or High Pavement. Boots the Chemist on the left was built in 1907. It was designed to blend in with the timber-framed buildings of the town but unfortunately the architect chose a style more appropriate to Ipswich than Shrewsbury.

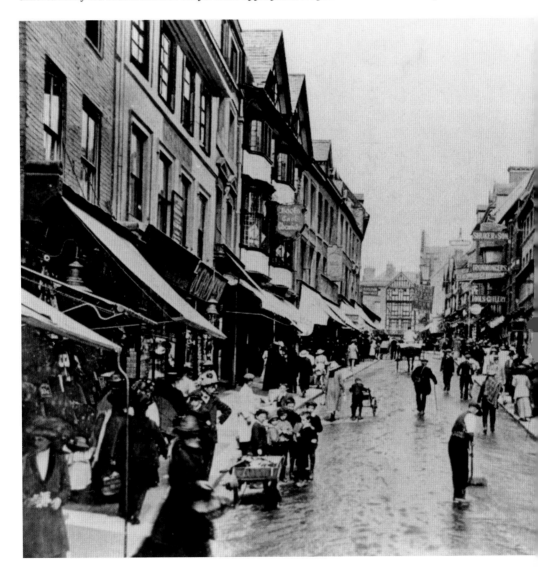

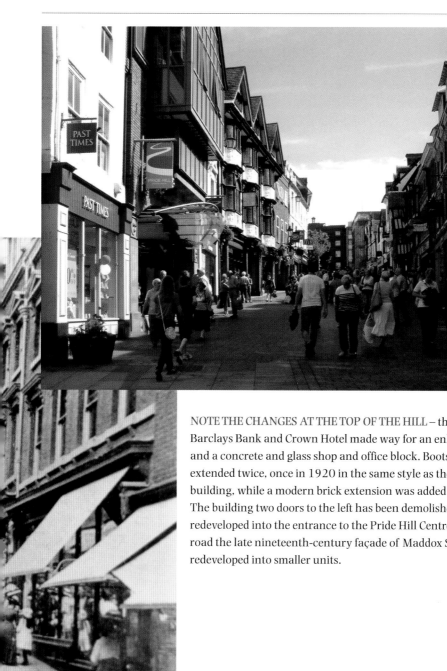

NOTE THE CHANGES AT THE TOP OF THE HILL – the old
Barclays Bank and Crown Hotel made way for an enlarged bank
and a concrete and glass shop and office block. Boots has been
extended twice, once in 1920 in the same style as the original
building, while a modern brick extension was added in the 1960s.
The building two doors to the left has been demolished and
redeveloped into the entrance to the Pride Hill Centre. Across the
road the late nineteenth-century façade of Maddox Store has been
redeveloped into smaller units.

ST MARY'S STREET &
PRIDE HILL JUNCTION

THE JUNCTION OF PRIDE HILL AND ST MARY'S STREET, *c.* 1905. The tower and spire of
St Mary's Church dominate the centre of this view. At 222ft 6in it is said to be the third highest
in the country, bettered only by Salisbury and Norwich cathedrals. The Crown Hotel was rebuilt
in the mock Tudor style in 1900 by the Church Stretton Hotel Company. The hotel was wrapped
round the authentic timber-framed building with the sun blinds. The shop belonged to Mrs Jane
Roberts who sold Scottish-made fishing tackle, and it was absorbed by the hotel in about 1925.
The confectionery shop on the left was also absorbed by the hotel in 1907. It belonged to Vincent
Crump and is advertising Royal Shrewsbury Cakes. On the corner is the post office, which also
housed the sorting office until 1900 and the telephone exchange until 1959.

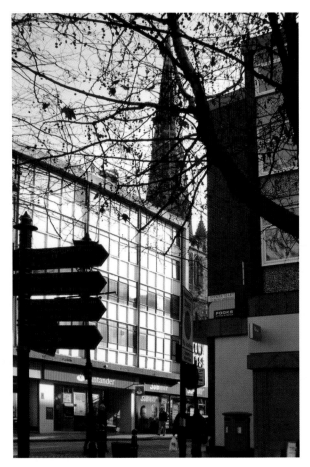

ST MARY'S CHURCH is just visible
between the new buildings and the
trees planted at the top of Pride
Hill. The Crown Hotel and the
post office were victims of the late
1950s and early 1960s changes
when some local councillors were
calling for 'Down with the old
and on with the new'. Built from
concrete and glass, Crown House is
occupied by shops and offices.
A new post office was opened
on the corner facing St Mary's
Street, while an MEB store
occupied the Pride Hill frontage.
The site is now occupied by
a Waitrose supermarket.

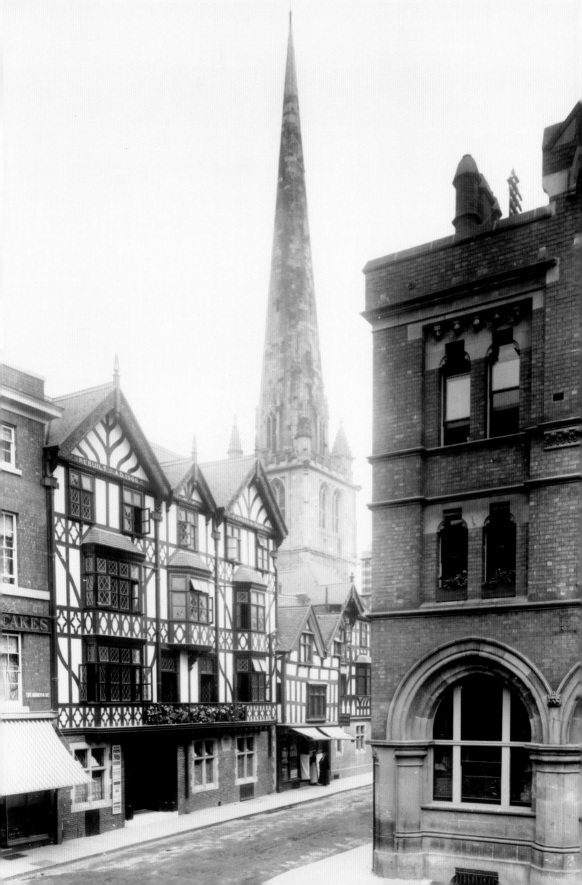

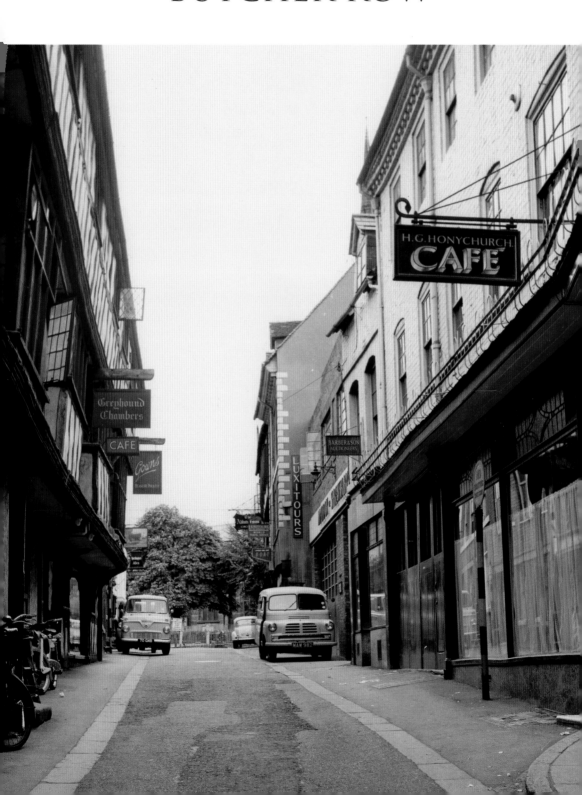

BUTCHER ROW, 28 JULY 1960. The eighteenth-century rebuild of St Alkmund's Church is just visible behind the trees at the top. On the right is Harold Honeychurch's café. He was listed as a pastry cook and had a confectionery shop just below on the corner of Pride Hill. Just above are Barber & Son, auctioneers and estate agents. The van on the right is parked outside the goods entrance and warehouse of Maddox Store. Just above is Luxitours World Travel Service, advertising BOAC flights. The van on the left is parked outside the Bull Inn whose sign once hung outside the Bull Inn in Abbey Foregate. In the timber-framed Greyhound Chambers is the ladies' costumiers run by Blanche Pockett and the Greyhound Café selling grills.

THE TIMBER-FRAMED building takes its name from an inn called the Greyhound that stood just below on the corner of Pride Hill. The café has been developed into the Royal Siam Restaurant that specialises in Thai food. Owing to structural faults Honeychurch's café and shop was taken down and rebuilt using as much of the old material as possible and in a similar style. Note the curve has been taken out of the ground floor but the windows on the upper floors are the same style. A hair salon has been put into Barber & Son's premises, while Maddox's goods entrance has been transformed into a café. The street is now nicely cobbled.

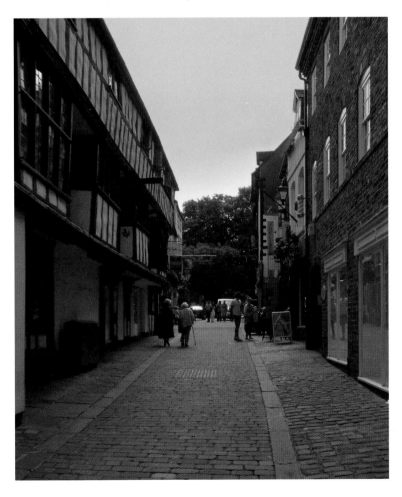

FISH STREET

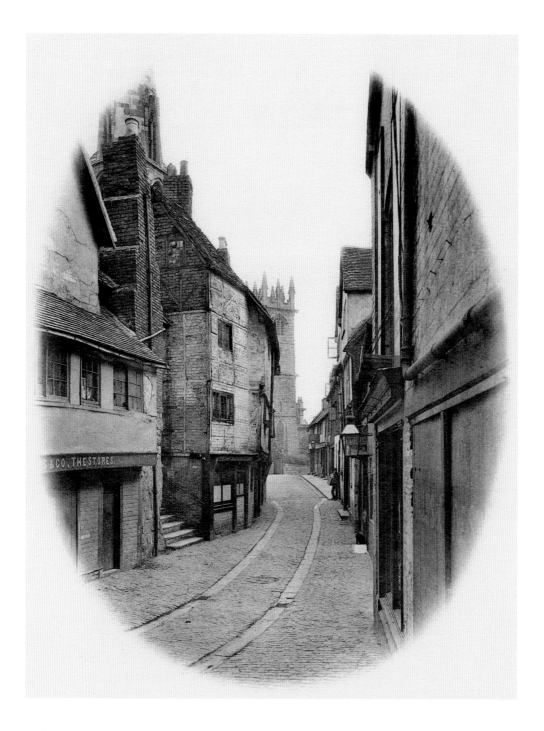

FISH STREET, *c.* 1895. The name of the street is derived from the fish boards that were set out along the wall between St Alkmund's and St Julian's churches from the fifteenth century.

St Julian's Church dates from the tenth century, though it was rebuilt with the exception of the tower in the Classical style in 1750. The bottom section of the tower dates from the twelfth century while the upper part was rebuilt in the fifteenth. The steps on the left are the Bear Steps, named after an inn of that name that stood opposite. The building to the right of the steps is the Oriel, described in 1921 as 'crumbling to decay'. The two doors to the left are water closets shared by the families who lived in the cottages up the steps.

BY THE 1960s the Bear Steps complex was in an extremely dilapidated state and it was suggested that demolition was the only option. Thankfully the newly formed Civic Society stepped in and restored the complex in 1968. For the sensitive way they achieved this, the society was given a Civic Trust Award for the renovation and they now have their offices in part of the building. On a fine summer's day with the hanging baskets in full bloom it is easy to see why Shrewsbury is known as the 'Town of Flowers'.

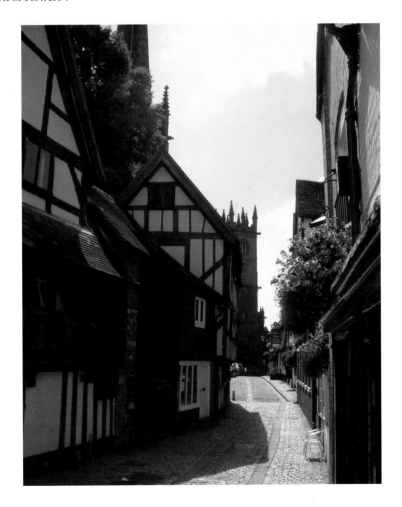

ST ALKMUND'S PLACE

ST ALKMUND'S PLACE, *c.* 1950. This street and St Alkmund's Square were once part of Old Fish Street that led from Butcher Row to the steps by St Julian's Church. St Alkmund's Church is on the left. Apart from the tower and spire the whole building was rebuilt between 1794 and 1795. Across the graveyard is the Bear Steps complex and behind and to the right of the large tree in the centre are a group of buildings removed in the 1950s to make access to Butcher Row easier. The passageway in the centre of the buildings was known as Burial Shut as coffins could be carried through from Butcher Row to St Alkmund's Graveyard.

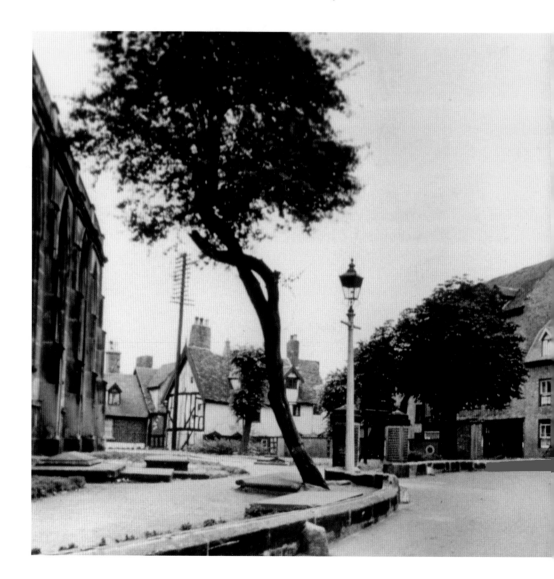

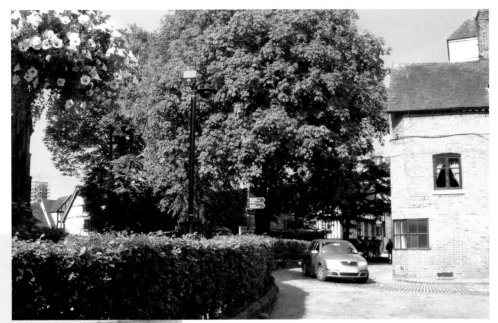

A HEDGE AROUND THE CHURCH and a large horse
chestnut tree obscure many of the buildings. Where the
demolished houses were you can now see through to the
timber-framed building on the corner of Butcher Row and
Fish Street. It belonged to the Abbots of Lilleshall Abbey
and was erected in about 1458. The car is turning into
Church Street that leads through to St Mary's Street.
The house on the corner has changed very little, just a
doorway bricked up and a corner window made smaller.

WYLE COP

WYLE COP, *c.* 1925. The building on the left on the corner of Dogpole is the London Coffee House, first licensed to sell McEwan's Scotch Ales in 1868. It was delicensed and removed in 1926 for road widening. The man with the straw hat on the right is standing by the entrance to the Raven and Bell Inn. The site was later used by Wyle Cop School, built in 1882. The shop next door belonged to Robert Stawart, a tobacconist. Just below is the Lion Hotel and on the corner is the beautiful timber-framed building known as Henry Tudor House. Henry Tudor is reputed to have lodged there while on his way with his army to Castle Bosworth where he beat Richard III to put himself on the English throne as Henry VII.

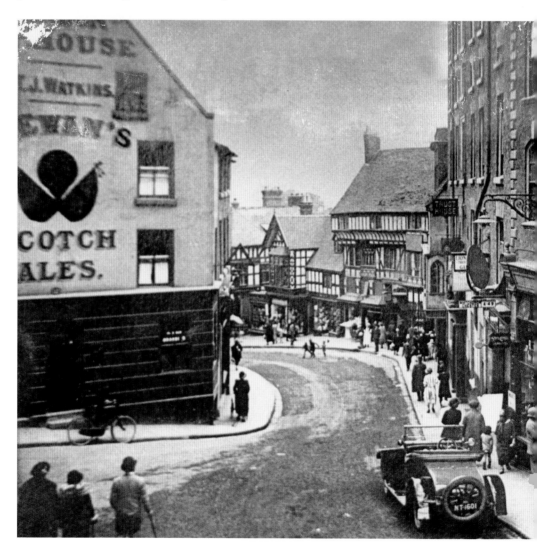

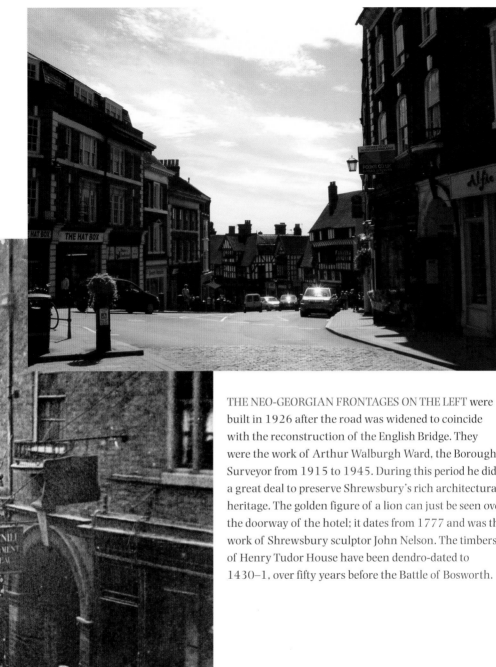

THE NEO-GEORGIAN FRONTAGES ON THE LEFT were
built in 1926 after the road was widened to coincide
with the reconstruction of the English Bridge. They
were the work of Arthur Walburgh Ward, the Borough
Surveyor from 1915 to 1945. During this period he did
a great deal to preserve Shrewsbury's rich architectural
heritage. The golden figure of a lion can just be seen over
the doorway of the hotel; it dates from 1777 and was the
work of Shrewsbury sculptor John Nelson. The timbers
of Henry Tudor House have been dendro-dated to
1430–1, over fifty years before the Battle of Bosworth.

WYLE COP

WYLE COP, *c.* 1895. The timber-framed house was stripped down to its frame in the 1890s and an old oak fireplace inscribed with the date 1603 was found hidden under plaster. Part of the building housed the Unicorn Inn, which was recorded in the eighteenth century. A new bowling green was opened at the rear in the middle of the nineteenth century with great ceremony. The green was lit by thousands of lamps, a military band played popular music and the evening ended with a magnificent firework display. The shop to the right is occupied by H. Powell a watchmaker and jeweller. Across the road at the junction of Beeches Lane is the confectionery shop of Thomas Phidduck Deakin. He was heavily involved in local politics and was Mayor of Shrewsbury twice.

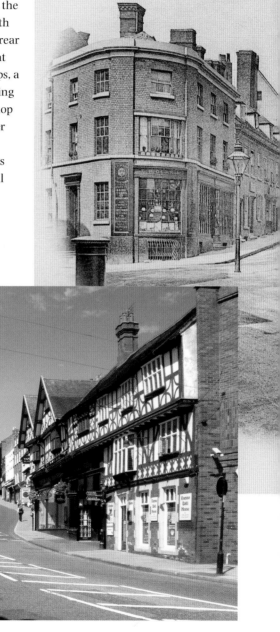

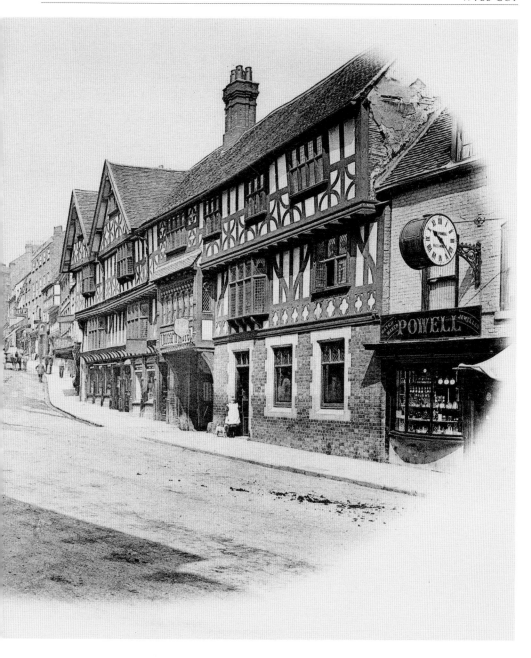

VERY LITTLE HAS CHANGED apart from the businesses. Powell's shop has been demolished, the gas lamp in the middle of the road has gone and the oriel window over the entrance to the Unicorn yard has been removed to allow entrance to high-sided vehicles. The shopfronts to the left of the arch have also been altered. The Unicorn Hotel closed in 1981 and was turned into a coffee bar before becoming the first Balti House in Shrewsbury in 1989. Road markings and traffic signs also litter the scene but note the postbox on the left is still there.

WYLE COP

WYLE COP, *c*. 1937. The timber-framed building seen here was Sherar's Mansion. It became one of the town's main inns, known as the Red Lion and is mentioned several times in St Julian's parish registers. In 1749 Pryce Jones advertised that he had stables at the inn for 100 horses and that a coach ran from there to London. The inn closed in about 1770 and the building was later converted into four units. A public house called the Hero of Moultan was opened in the right-hand section in 1850. The name refers to a local hero Sir Henry Benjamin Edwards who gained fame for his courage and leadership in India in 1848.

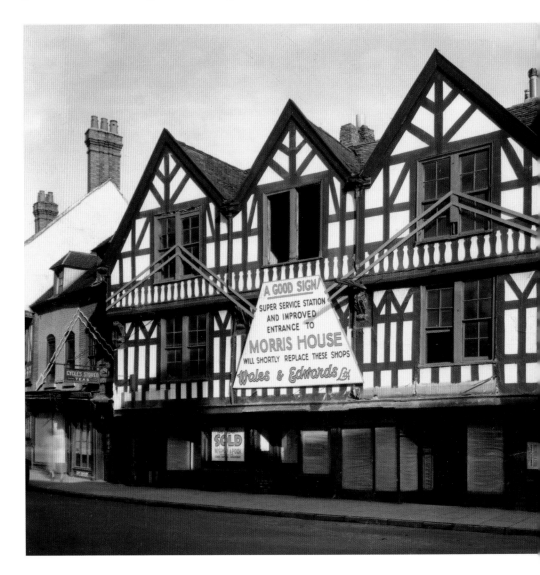

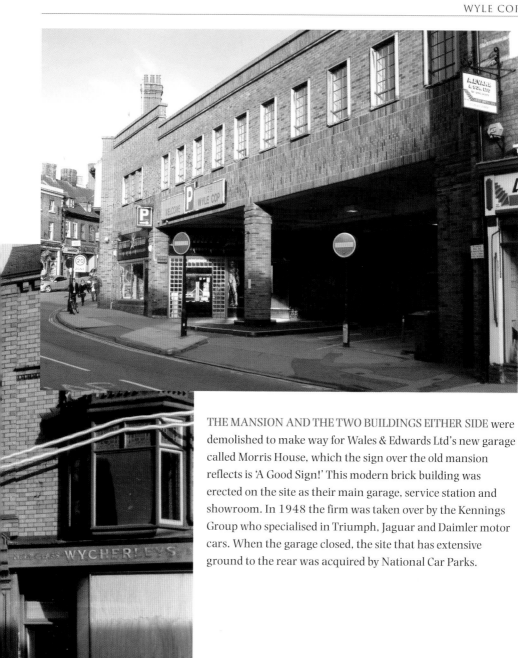

THE MANSION AND THE TWO BUILDINGS EITHER SIDE were demolished to make way for Wales & Edwards Ltd's new garage called Morris House, which the sign over the old mansion reflects is 'A Good Sign!' This modern brick building was erected on the site as their main garage, service station and showroom. In 1948 the firm was taken over by the Kennings Group who specialised in Triumph, Jaguar and Daimler motor cars. When the garage closed, the site that has extensive ground to the rear was acquired by National Car Parks.

HIGH STREET

HIGH STREET, *c.* 1965. On the left is Peacock Passage which takes its name from an inn that once stood at the Princess Street end of the passage. Behind the lorry is Langford and Davies's butcher's shop, while the house next door advertising Butlers' Ales is the Criterion Inn, which was first recorded in 1879. Next to the inn G.H. (Happy) Christmas had a sports, games and toy shop; and beyond that is the Unitarian Church, where Samuel Coleridge preached and Charles Darwin worshipped. The impressive mock Tudor building is the front entrance to Della Porta's departmental store while beyond is the Shirehall, The Square and Ireland's Mansion.

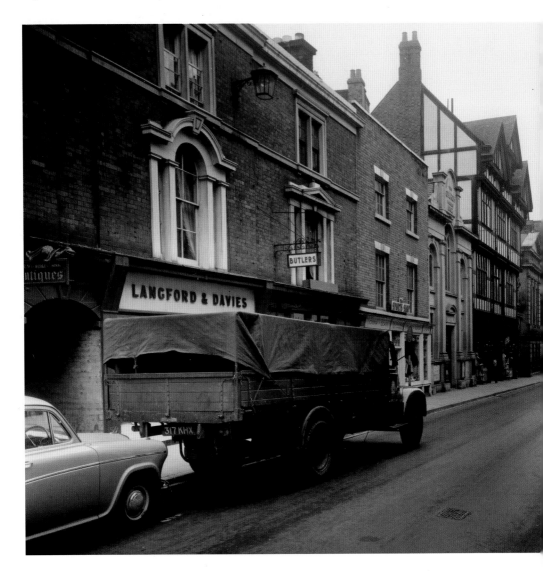

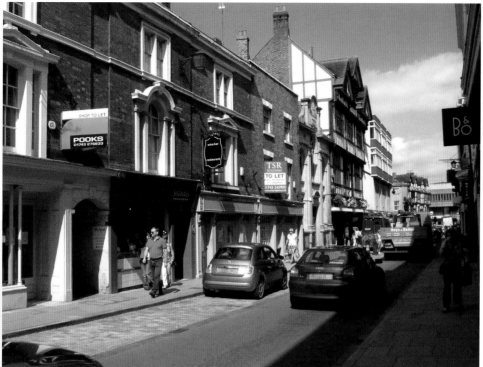

THE WIDTH OF THE ROAD HAS BEEN NARROWED by the insertion of bus stops and loading and parking bays. The volume of traffic has also increased. In the 1970s Sidoli Bros Ltd, who owned a number of cafés in the area, redeveloped the Criterion and Christmas's shop into a steak bar after the properties had been empty for several years. The restaurant was later converted into a theme pub called the Black Bull in Paradise, which has since closed and the premises is now being adapted for some other purpose. Della Porta's store was taken over by House of Fraser and is known as Rackhams, while the Shirehall was replaced in the 1970s by a modern block of offices and shops.

THE SQUARE

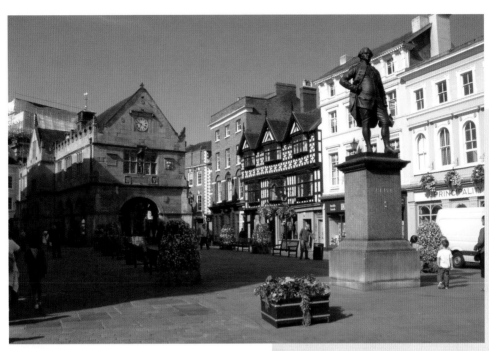

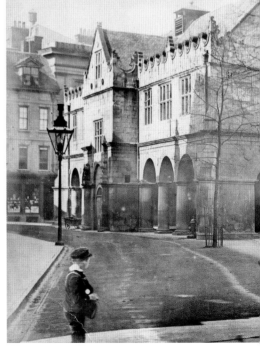

THE SQUARE, *c.* 1880. In the middle of the thirteenth century The Square was developed into the town's principal market and administration area. The old Market Hall was built in 1596 so that corn could be sold on the ground floor while Welsh wool and cloth was sold in the upper storey. The right-hand section of the timber-framed building is the Plough Inn that was recorded in the seventeenth century. The left-hand section was occupied by Hughes & Son who were boot makers. Millard Harding & Co. were silk mercers and linen drapers. In 1890 they were the sole distributors of Hudson's Victoria Cloths as ordered by Her Majesty's Household.

THE SQUARE WAS PAVED OVER and pedestrianised in the summer of 1996 and is now the setting for special events. Millard Harding's shop was taken over by H.E. Grocott and was known as 'The Fashion Centre of the County', selling a wide range of ladies' garments until they closed in the early 1960s. The shop was then broken down into smaller units. Note the new top storey to the Plough, which was added by Mr Price, a builder from Frankwell in 1898. Its design fits in so well with the old it fools all but the shrewdest of tourists. The inn took over the whole of the building until it closed in 2004. Lord Clive's statue was unveiled in January 1860. It was the work of Italian sculptor Baron Marochetti and cost £2,000.

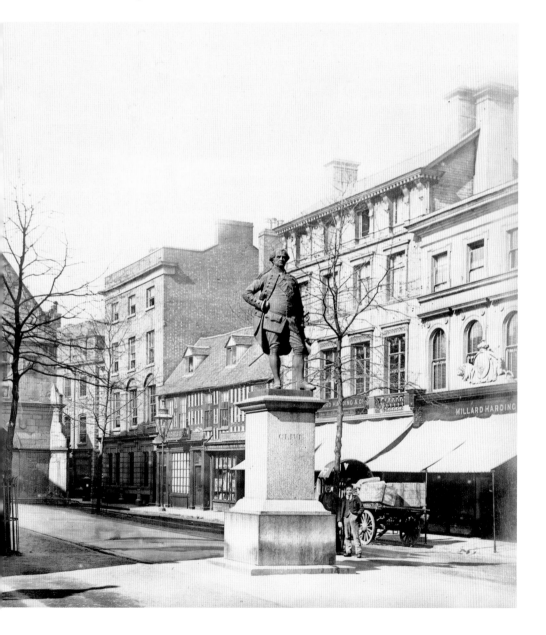

PRINCESS STREET

PRINCESS STREET, *c.* 1940. This is a view of the new extension of the Shirehall. They were known as the County Buildings and were the work of newly appointed County Architect A.G. Chant. The building was erected in three stages; the central portion was completed in 1935, the section on the corner on the site of Lloyd's Mansion was finished in 1937, while the section at the top of Princess Street was ready in 1939. The three sections were linked together on the upper floors to form one large suite of offices and were formally opened in 1940. For selling the council Lloyd's Mansion, Della Porta were able to develop a new superstore with a frontage on High Street and a rear entrance and shop windows under the colonnades in Princess Street.

ONLY THE TOP section of the County Building still stands and is occupied by Rackham's store, which took over from Della Porta. The new office block and shop were ready for occupation in 1973. This corner section houses the Job Centre and the entrance to an antiques arcade. Dyas Bros, on the right of the old view, were listed as drapers – note the sign on the old view advertising the 'Dress & Cloth Warehouse'. They now trade under the name of Jane Dyas, an exclusive ladies' fashion house which celebrated its 120th anniversary in 2011.

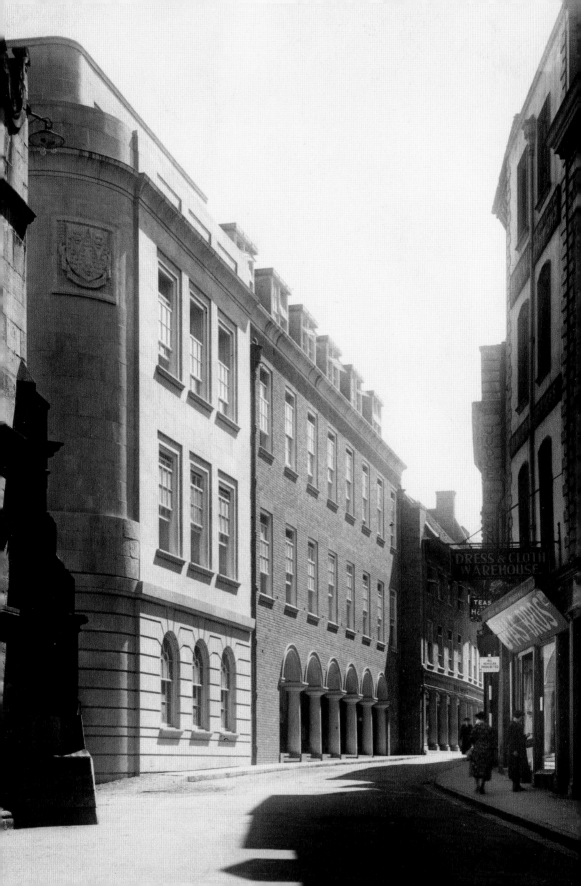

MARKET STREET

MARKET STREET, *c.* 1950. This section of road is from the corner of Swan Hill on the left to Shoplatch and the Victorian market hall. The building in the centre is the West Midland Trustee Savings Bank. The bank evolved from the Abbey Parish Savings Bank founded in 1816 and the County Savings Bank founded two years later. They amalgamated in 1839 and moved to this site in 1906. The sign to the left advertises Marston & Son Decorators and the shop below was run by Edwin Lightfoot, an antiquarian and second-hand bookseller. The bank also purchased this site for an extension of their premises. The large building at the bottom is the George Hotel. It was once known as the George and Dragon and behind the Victorian façade, parts of the building dated back to 1615.

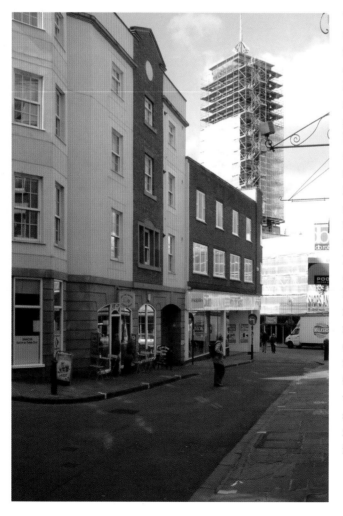

THE SCENE HAS completely changed. The bank and the corner premises were developed into a modern bank in 1960. This block of apartments and a café on the ground floor replaced the bank but work was stopped on the site when a Mallard duck made her nest there and hatched a brood of young ducklings. Tesco opened their first supermarket on the George Hotel site on 21 September 1965. The ceremony was performed by Miss Silver Gill who represented Gillette safety razors. The offices above were occupied by the inspectors of the Sun Alliance Insurance Group until their new office was built on the Shirehall site. On Shoplatch is the modern market hall covered in scaffolding.

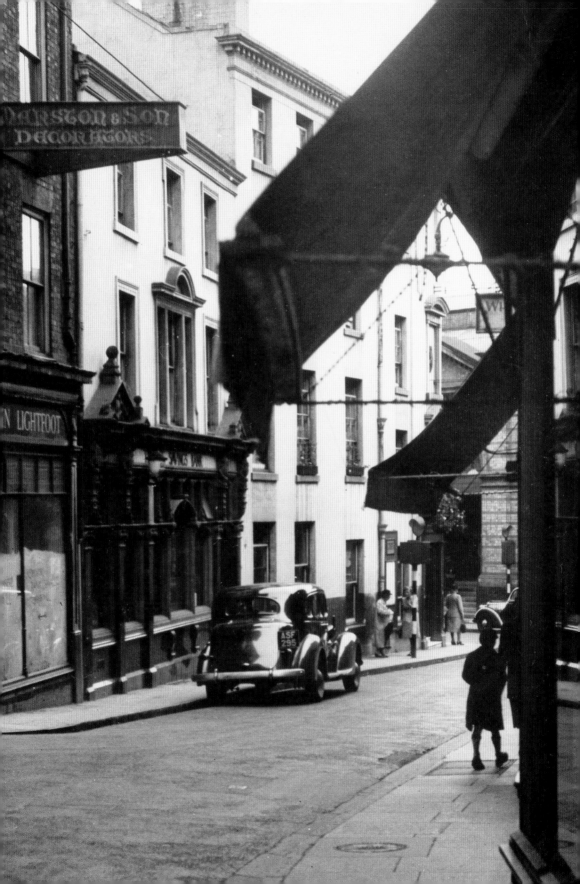

HIGH STREET

HIGH STREET, *c.* 1890. The building on the left on the corner of The Square is the Salop Old Bank owned by Eyton, Burton, Lloyd & Co. Just beyond is Ireland's Mansion and facing up the street is Lloyd's Bank on Pride Hill. The bank moved into that building in 1876 after removing the plaster from the timbers and modernising the ground floor. The timber-framed buildings on the right are known as Owen's and Cartwright's Mansions. The far one was erected by Robert Owen the elder, a wealthy wool merchant in 1592. The one nearest the camera takes its name from John Cartwright and was erected six years later. The timber-framed buildings and the one on the corner of Pride Hill were occupied by Richard Maddox, while the one in the middle was occupied by William Walker who had a printing works in Fish Street and Grope Lane.

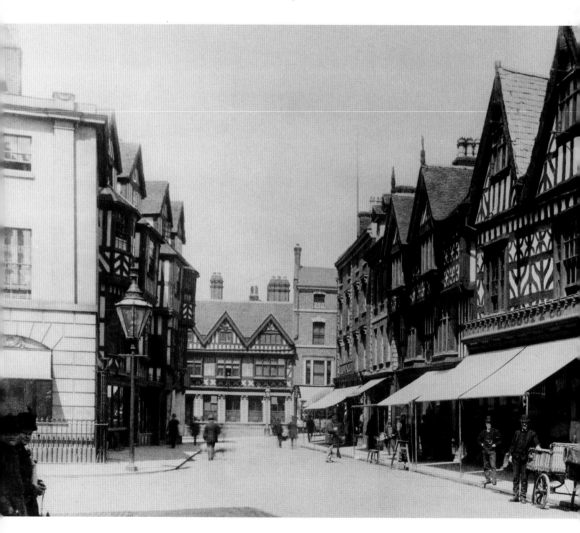

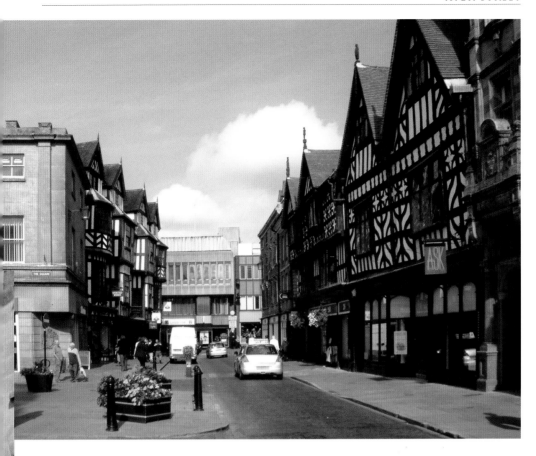

THE MOST OBVIOUS DIFFERENCES are the road, which was narrowed and partially cobbled in 1999 as a traffic-calming measure, and the modern building at the end of the High Street. Lloyd's Bank replaced their timber-framed façade with this ultra-modern front in 1965. Its architecture won a Civic Trust Award in 1968, as it was supposed to reflect similar features to the timber-framed buildings that surrounded it! Note the section of building on the far right. In the old view it housed the Salop Fire & Shropshire & North Wales Insurance Office. The office was replaced with a Flemish style building in 1891 a year after the company had merged with the Alliance Assurance Company Ltd.

MARDOL HEAD

MARDOL HEAD, *c.* 1960. The lorry is just passing the junction to High Street on the right and travelling up Pride Hill, which was still open to one-way traffic. On the far corner is Maddox's department store; while on the other is the Royal Insurance building with its domed turret on the roof. Below are the businesses of Pleasance and Harper, which was a goldsmiths, jewellers and diamond merchants founded in 1879; Kendall's, who sold ladies' rainwear, and William Major Ltd who sold gents', ladies' and children's clothing. They were a local firm who had branches in Oswestry and Welshpool.

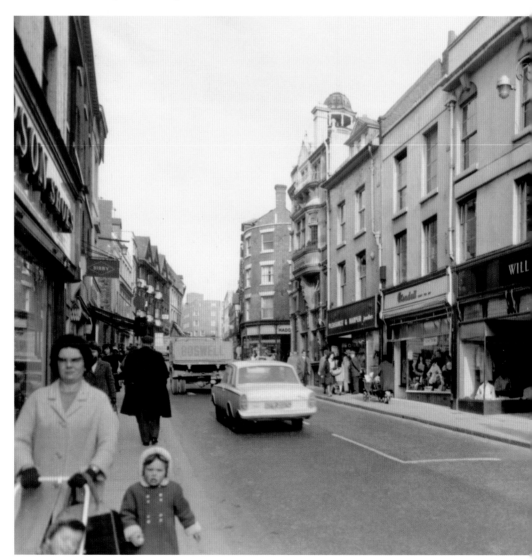

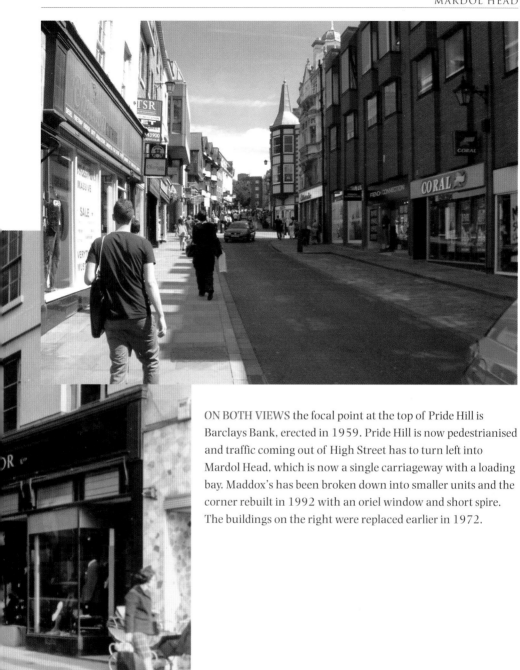

ON BOTH VIEWS the focal point at the top of Pride Hill is Barclays Bank, erected in 1959. Pride Hill is now pedestrianised and traffic coming out of High Street has to turn left into Mardol Head, which is now a single carriageway with a loading bay. Maddox's has been broken down into smaller units and the corner rebuilt in 1992 with an oriel window and short spire. The buildings on the right were replaced earlier in 1972.

MARDOL HEAD

MARDOL HEAD, *c*. 1975. The top of Mardol was pedestrianised in the 1970s sending traffic down Claremont Street and blocking entry to Mardol Head and Shoplatch. A large raised garden with seating was placed in the centre, which was ideal for weary shoppers on a hot summer's day. The National Westminster Bank was built on that site in 1926 while the mock Tudor building to the right has the date of 1856 in the plasterwork above the second storey. Between the buildings is the Gullet Passage leading to The Square. Once an open stream ran down the passage, draining a pool in The Square to the river and it is believed that the name is derived from an old word 'golate' meaning a channel or ditch.

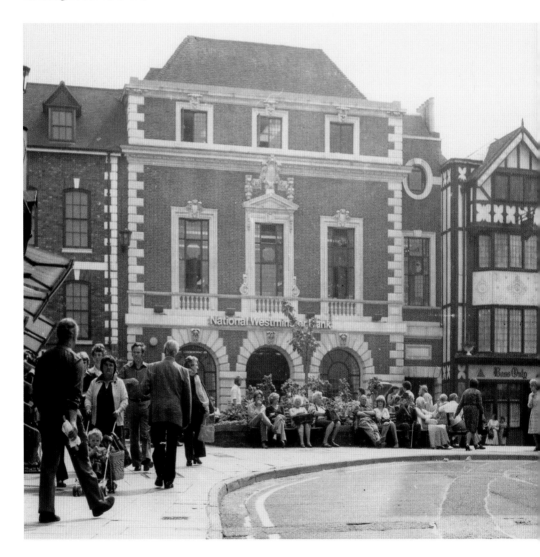

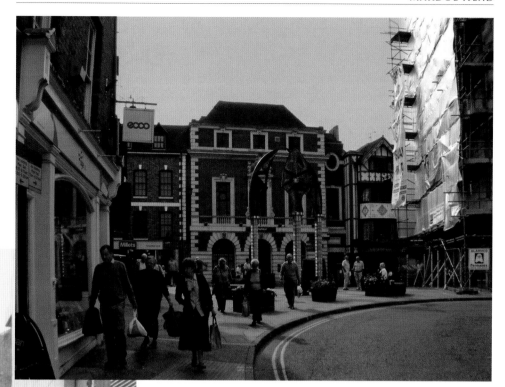

THE GARDEN AND BENCHES have been replaced by a piece of modern art known as Darwin's Gate. It cost £80,000 and when viewed from a certain angle the three sections fit together to form a Saxon helmet or a Norman window. It caused a great deal of controversy when it was unveiled in November 2004 with many people complaining it was a 'hideous monstrosity' and that it should be shipped to the Galapagos Islands! The mock Tudor building is an inn opened just before the Victorian market hall was completed in 1869. It was first recorded as the Market House and subsequently the Market Inn and the Market Vaults. In 1985 it incorporated a smaller inn called the Hole in the Wall that stood in Drayton's Passage. After the work was completed the new complex took the name of the smaller inn.

MARKET HALL

THE VICTORIAN MARKET HALL, MARDOL HEAD, *c.* 1961. The building was opened by the Mayor Thomas Groves on 29 September 1869. It was a mixture of architectural styles and was built with red, white and black bricks with a Grinshill stone dressing. Over the entrance to the corn exchange was a sculpture by Landucci showing Peace and Plenty holding a sheaf of corn. The tower rose to a height of 151ft and the clock, made by Joyce of Whitchurch, could be seen all over the town.

THE MARDOL END OF THE NEW BUILDING was developed first while the market continued trading in the old Belstone end. Once the Mardol end was completed the market traders moved in and the Belstone end was redeveloped. The new market hall was designed by David du R. Aberdeen & Partners and developed by Second Covent Garden Property Co. Ltd at a cost of around £1 million. After the opening one local newspaper commented, 'it replaces that Victorian monstrosity put up less than 100 years ago.' It has now been refurbished, the working taking place in 2011 and 2012.

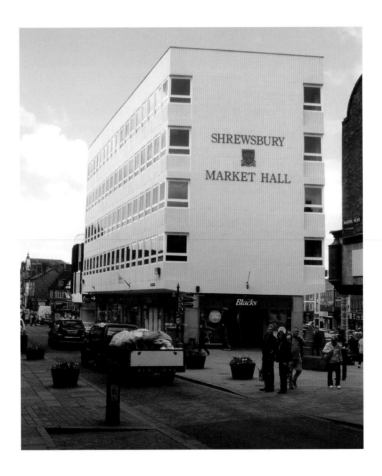

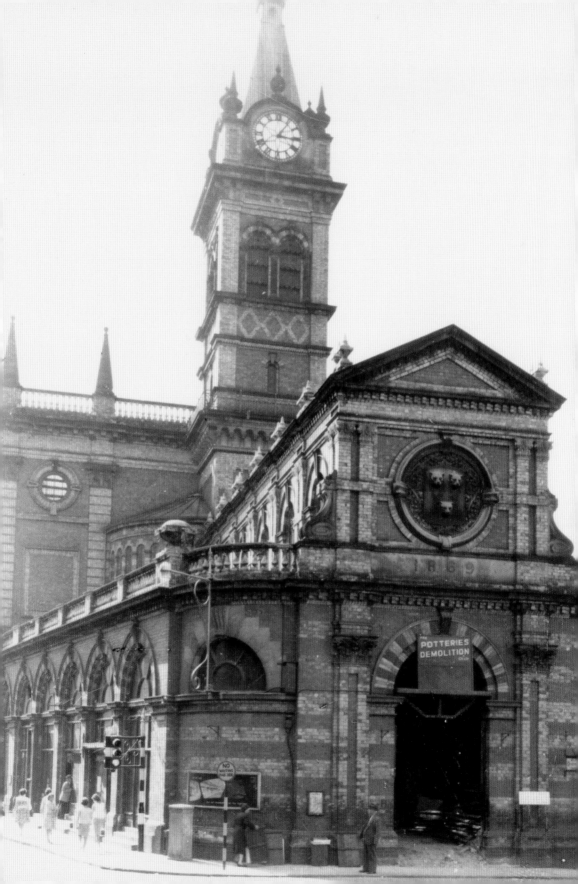

SHOPLATCH

SHOPLATCH, *c.* 1945. The Theatre Royal or the County Theatre stood at the end of Shoplatch, facing down Belstone. It was erected on the site of Charlton Hall in 1834. The ground floor once contained a tavern called the Shakespeare (which was delicensed in 1913) and several shops. The frontage was highly ornamented and included three sculptures of Shakespeare in the middle, flanked by the Tragic and Comic muses. The theatre was adapted into a cinema in about 1908 using back-screen projection. This view was taken just after a devastating fire in June 1945. The last film to be shown was *Mr Deeds Goes to Town*, starring Gary Cooper and Jean Arthur.

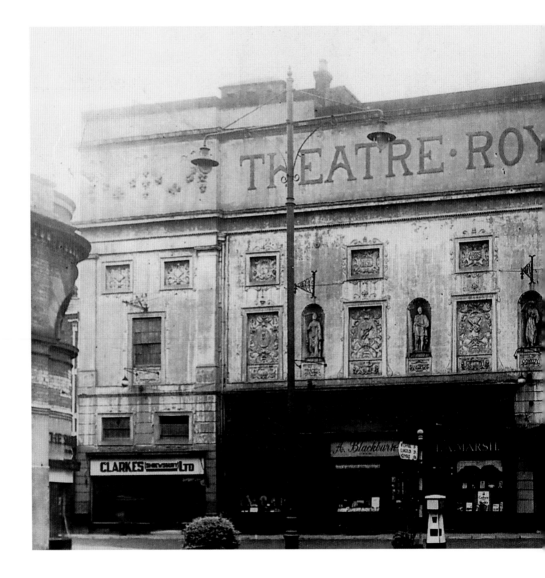

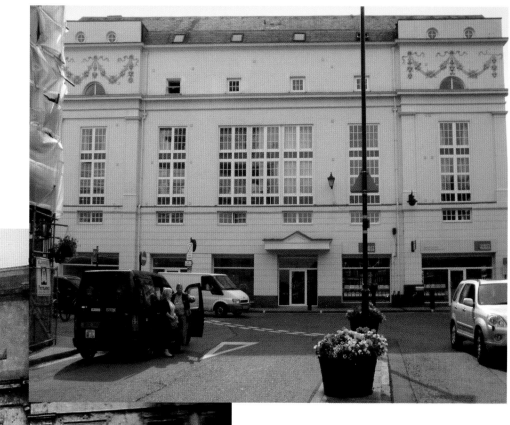

AT FIRST IT WAS HOPED TO REOPEN THE THEATRE but too much damage had been caused by the fire for this to be possible. Most of the interior was destroyed and there was structural damage to the front. A great deal of the façade was rebuilt and all the ornamentation, except for the scrolls on either end of the building, was removed. Although the Tragic and Comic muses were lost in the rubble, Shakespeare survived to ornament a rockery just outside Shrewsbury. Since the fire, furniture dealers S. Aston and Kingsway have both occupied the building. It was then occupied by Poundstretcher before the ground floor was converted into smaller shops while the upper floors were redeveloped into smart apartments.

NEW SHIP INN YARD

NEW SHIP INN YARD, Barker Street, *c.* 1910. The photographer has his back to the inn and the passageway leading to Barker Street and is looking towards the Hill's Lane entrance on the right. The timber-framed building on the left is Rowley's House while the brick building behind is Rowley's Mansion. The mansion is one of the first brick-built houses in the town and was scheduled to survive the demolition of the 1930s, while the house was due to be demolished with the other buildings in the view. At the time it was described by historian H.E. Forrest as 'terribly dilapidated: almost ruinous'. Arthur Ward, the Borough Surveyor, recorded, 'The timbers in the walls of the ground floor, most of which had decayed or been removed, had been replaced by rough brickwork.'

THE NEW SHIP INN YARD is now part of a car park and the view is open to the houses on Hill's Lane. The inn was known as the New Ship Inn to distinguish it from the Old Ship Inn that stood nearby in Bridge Street. Rowley's House survived thanks to the foresight of Arthur Ward and the

generosity of Morris & Co., who transferred the building to the Borough Council on 29 September 1931. With a few minor alterations Ward was able to adapt his plans to conserve and repair it using materials from demolished buildings. It now houses a museum and tourist office. However, these are due to move when the new museum is ready in the refurbished Music Hall and the fate of this building is uncertain.

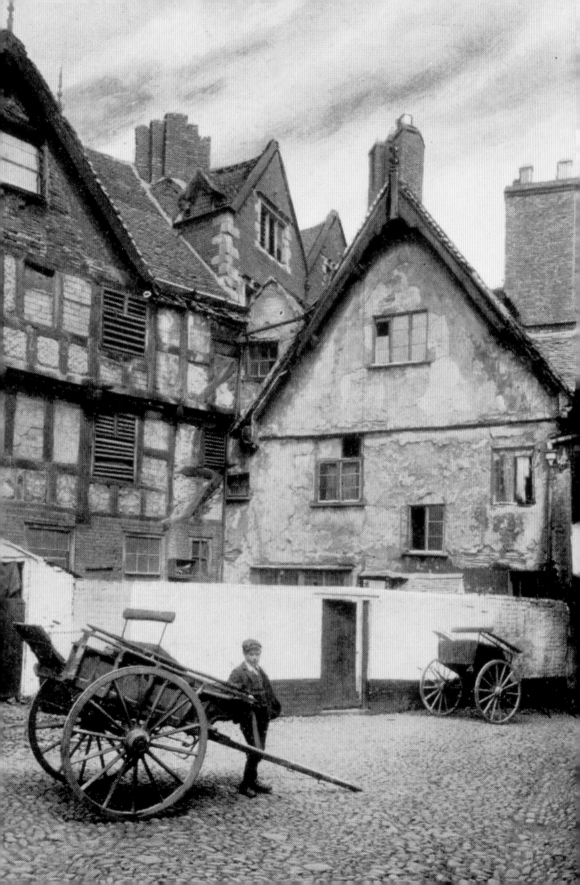

CLAREMONT BANK

CLAREMONT BANK, *c.* 1960. The road was laid out in the last decade of the eighteenth century. It is thought the name comes from the Norman/French 'clare', meaning a residence and 'mont', a hill. The road ended abruptly at the junction of St Austin's Friars on the right, which led to the junction of Bridge Street and Barker Street. Lower Claremont Bank that runs past the demolition work was not put through until after the Second World War. The buildings with the chimney are part of the Circus Brewery bought by Morris & Co. in 1919. The rear of the site is being converted into a garage to keep and maintain their fleet of delivery vans.

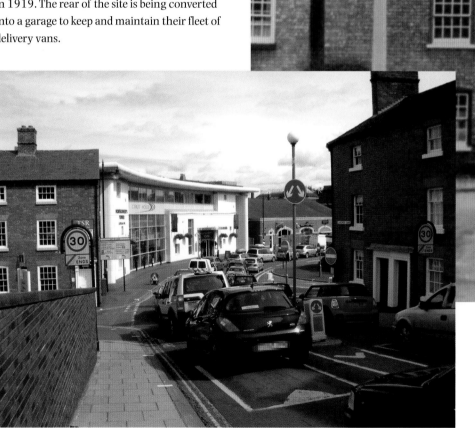

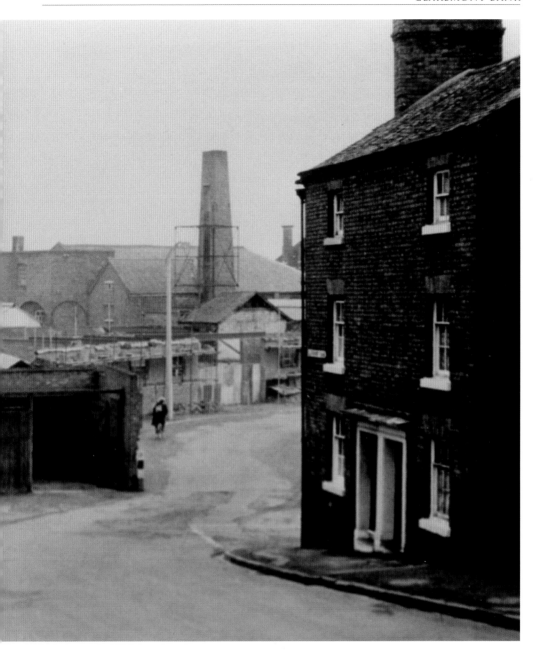

THE BUILDINGS AT the bottom of Claremont Bank have hardly changed, just the door and the window of the house on the left have been reversed and the chimney stack moved to the middle. In 1966 Morris & Co. built a new warehouse on the site of the brewery, which they extended in 1973. The warehouse closed in about 1995 and the site was redeveloped into a leisure area with a nightclub, restaurants and bars. The modern white building is Cirrus House, which houses a complex known as Montgomery's Tower.

MARDOL QUAY

MARDOL QUAY, *c.* 1910. This establishment was known as the Borough Carriage Works, the Motor House or Withers' Garage. It was founded in about 1871 by William Withers and originally manufactured horse-drawn coaches, carriages and traps. They also supplied commercial vehicles such as bread and milk delivery floats and had another works in Hill's Lane. The building was quickly adapted for the use of the motor car by Samuel Withers and was one of the biggest garages in town. It was the sole agent for Vulcan cars and official repairer for the Automobile Club of Great Britain Incorporated, the forerunner of the RAC.

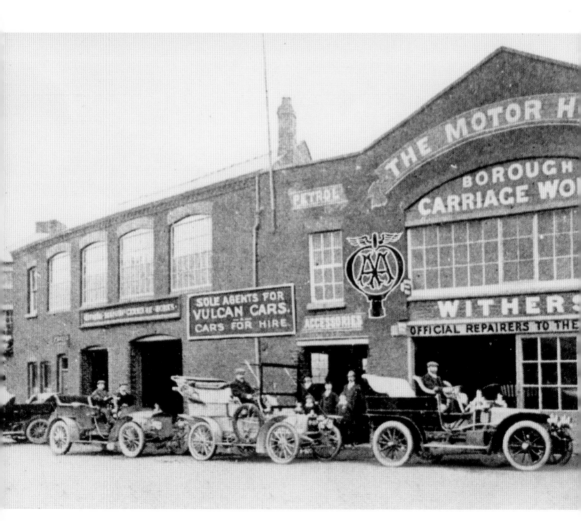

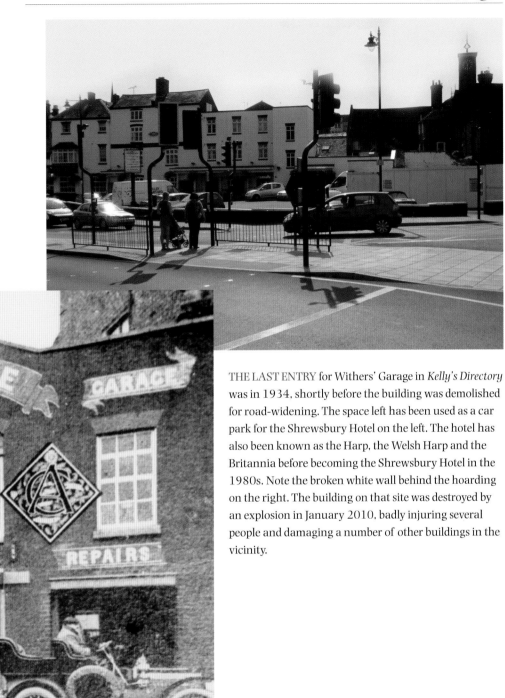

THE LAST ENTRY for Withers' Garage in *Kelly's Directory* was in 1934, shortly before the building was demolished for road-widening. The space left has been used as a car park for the Shrewsbury Hotel on the left. The hotel has also been known as the Harp, the Welsh Harp and the Britannia before becoming the Shrewsbury Hotel in the 1980s. Note the broken white wall behind the hoarding on the right. The building on that site was destroyed by an explosion in January 2010, badly injuring several people and damaging a number of other buildings in the vicinity.

MARDOL QUAY

MARDOL QUAY, *c.* 1930. Mardol Quay was set up in 1607 by Rowland Jenks. The site was later occupied by Frank Gethin who opened this garage in 1921 after returning from India. He was the sole proprietor of the garage until he sold the site to the council for road-widening in 1958. Mr Gethin, who lived in Woodfield Road, was a Borough Councillor from 1930 until his death in 1959 at the age of seventy-three. Above the garage on the left is the Welsh Bridge and Bridge House. To the right of the timber-framed house is Frankwell Forge, occupied by H. & E. Davies.

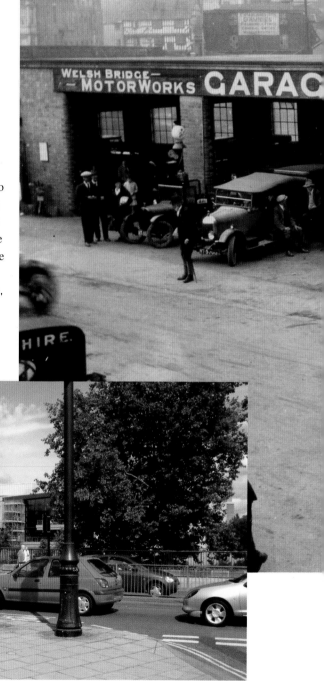

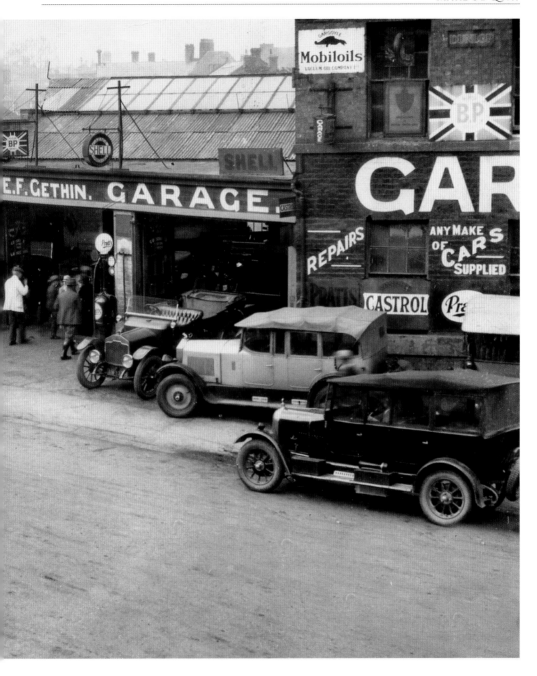

THE ROAD HAS BEEN WIDENED and the site developed into a pleasant riverside park. The timber-framed house is still visible in Frankwell and the tower of St George's Church is on the horizon. The site of the forge has been incorporated into the controversial Theatre Severn. The building dominates the area overshadowing many historic buildings around it. However, the interior is spectacular and a marvellous venue for a variety of entertainment.

CATTLE MARKET

SHREWSBURY CATTLE MARKET, *c.* 1925.
The photographer is looking towards Smithfield
Road on the left and the bottom of Meadow
Place on the right. The tall three-storey building
facing towards the sheep pens is the Albert
Hotel that has stood there from about 1856.
The market was opened by the Mayor on 19
November 1850 at a cost of £20,000. The event
was celebrated by over a hundred gentlemen,
traders and farmers who enjoyed a traditional
English dinner held at the Britannia.

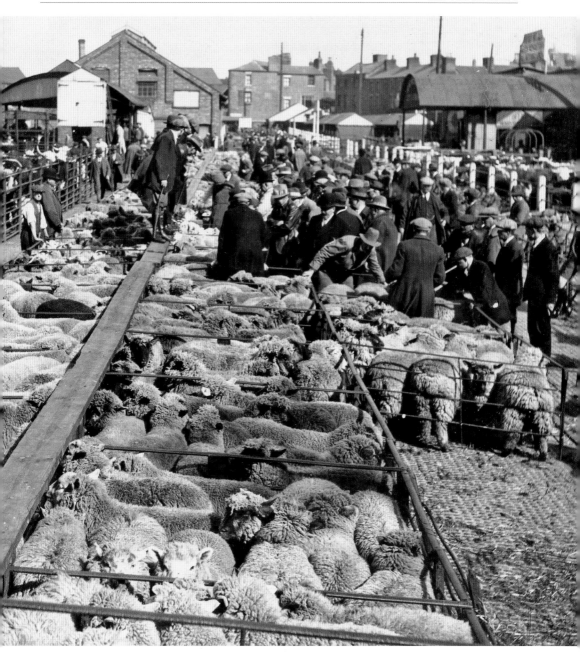

THE LAST SALE was held at the market in April 1959 before it finally moved to its new site in Harlescott. The area was then developed into the Riverside Shopping Centre and multi-storey car park. In about 1989 the bus station was moved to this site from Barker Street, much to the disapproval of traders and shoppers in the general market hall who believed the move took away a great deal of trade. However, the new bus station does give shoppers a direct link with the Darwin Centre and the main shopping area of the town.

COTON HILL

COTON HILL, *c.* 1895. This view was taken from the Frankwell side of the river. The timber-framed Benbow House was the birthplace of the gallant Admiral Benbow who was born there in about 1650. He hung his key on a tree in the garden the day he ran away to sea as a boy. The key was later preserved in a box on the side of the house. In the late nineteenth century the house was vicarage for St Mary's Church. In July 1911 Mark Davies, the proprietor of a garage on Wyle Cop, opened another branch in the garden of the house. The garage was acquired by Furrows in 1919. The name of the firm originates from the furrows ploughed by the Fordson tractors, which Cyril Harrison-Watson, the founder of Furrows, used for a government food production scheme during the First World War. The chimney to the right belonged to the pumping station that topped up the water columns for the steam engines.

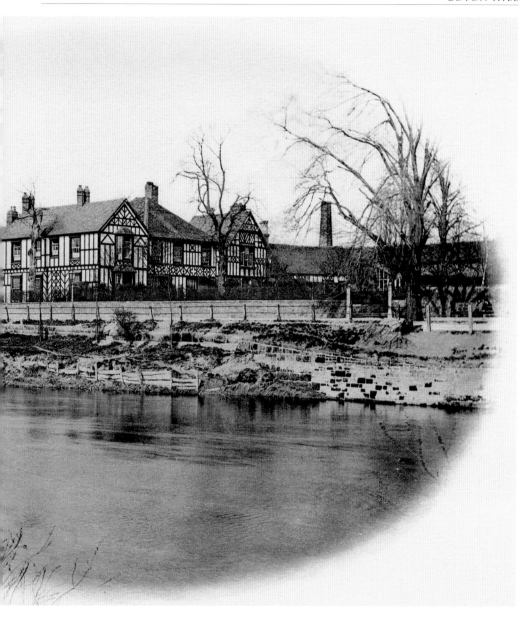

MOST OF THE cottages to the left of Benbow House were demolished over a number of years as Furrows expanded their business. Benbow House was also demolished in 2005 after Furrows moved their garage and showrooms to a purpose-built site in Harlescott. Over the years the house had been altered and adjusted to meet the needs of the business so that very little of the original building survived. However, Benbow's key has been preserved in a box in the forecourt of the new buildings.

COTON HILL

COTON HILL AND CHESTER STREET, *c*. 1980.
This view was taken from the top of Telephone
House on Smithfield Road. The house, bottom
right, is opposite the bus station. Just above are the
buildings belonging to George 'Woppy' Phillips,
the scrap iron dealer. The part overhanging the
river was put in when it was a timber yard so
that longer tree trunks could be put through the
sawmill. The cars are in the yard behind Charles
Clark's garage while the partly demolished
building in the centre is Southam's Brewery. Above
are buildings in the railway goods yard and to the
right the signal-box and railway offices. Towards
the horizon are the towers of the fire station,
St Michael's Church and the flax mill.

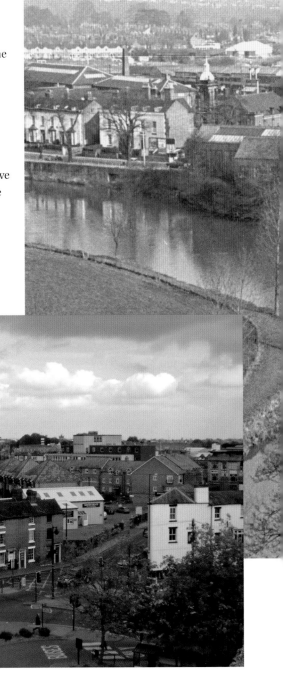

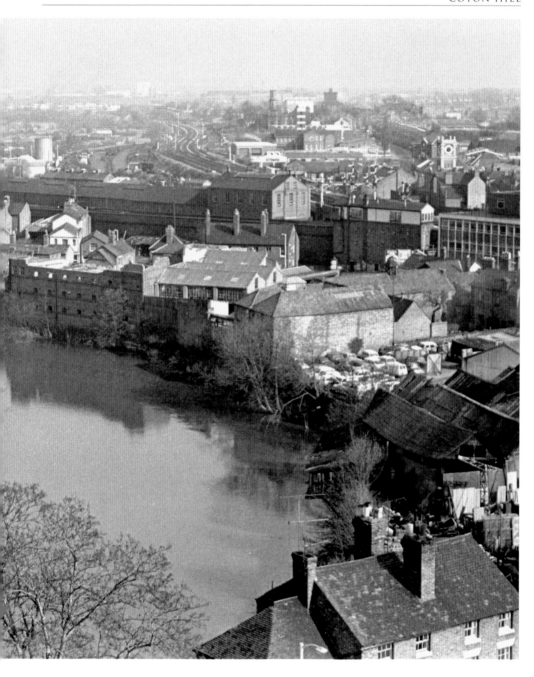

THE MODERN VIEW is taken from the top of the multi-storey car park, which is lower and further back than Telephone House that was demolished in 2002. Simon Boyd's new premises occupy the scrap yard, while Clark's site has been redeveloped into riverside apartments. Just to the left between the trees is the Gateway complex on the site of the brewery. The fire station tower and flax mill are still visible among the trees that now hide the church.

SMITHFIELD ROAD

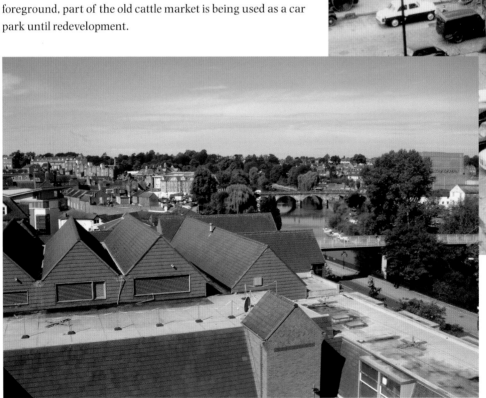

SMITHFIELD ROAD, *c.* 1965. This view towards the Welsh Bridge was also taken from the top of Telephone House. The bridge was built further downstream than the old one. It was designed and erected by Tilley and Carline in 1795 for around £8,000. The building in the centre is the Victoria Hotel advertising Border Ales. It was first licensed in 1856 just after the opening of the cattle market to cater for the needs of the farmers on market day. It closed soon after the market moved and was demolished in May 1965. Behind, selling Southam's Ales, is the Smithfield Hotel. It was first recorded as the Globe but changed its name in 1916. The white building on the left is occupied by C.R. Birch & Son who have been selling general hardware and ironmongery for three generations. In the foreground, part of the old cattle market is being used as a car park until redevelopment.

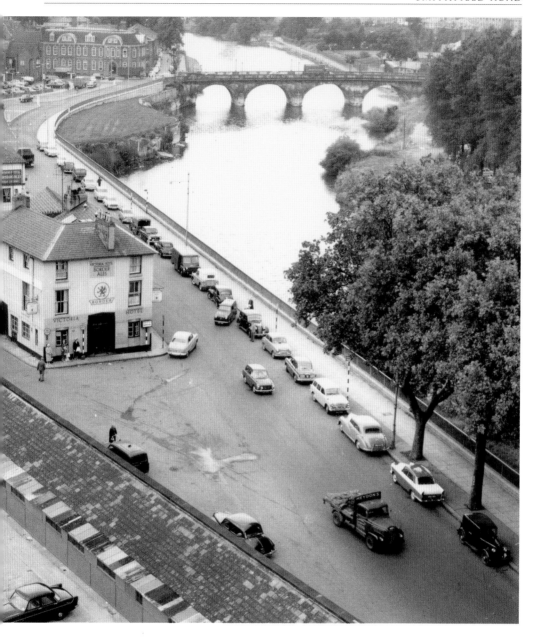

THIS VIEW WAS also taken from the top of the multi-storey car park. The cattle market and Victoria Hotel sites are now covered by the Riverside shopping precinct. Birch's shop is still open and can just be seen between the ridges of the new roof line. The Smithfield Hotel is still open but hidden behind the new buildings and trading under the name Salopian Bar. To the left of the Welsh Bridge on both views is the impressive head office of Morris & Co. It was built on the site of the Circus Inn and brewery in 1919. A new footbridge linking Frankwell car park and the Riverside Centre was built upstream of the Welsh Bridge in 1979.

THE QUARRY

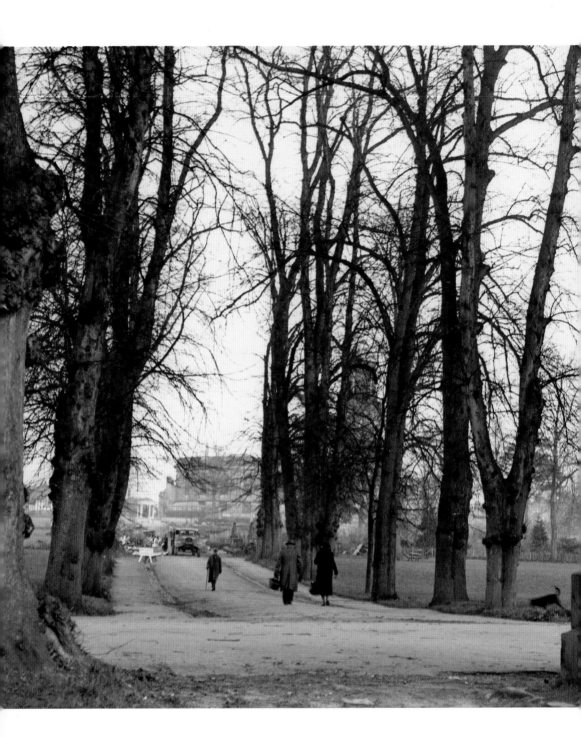

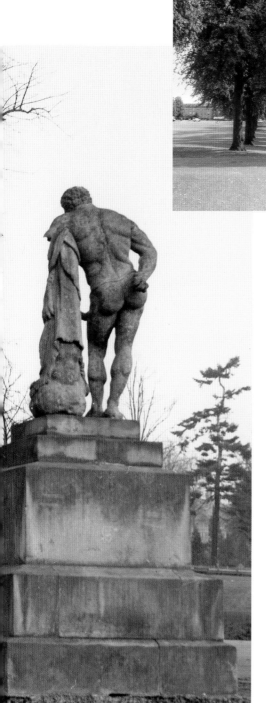

THE QUARRY, *c.* 1946. The photographer is looking up Central Avenue towards the war memorial and St Chad's Church. The old lime trees that were planted by Thomas Wright in 1719 are being felled as many were in a dangerous state. Several of the trees were hollow and some stood over 150ft tall and were covered in mistletoe. The statue of Hercules was cast in Rome and until 1804 stood in front of Condover Hall. It was bought by the governor of Shrewsbury Prison and was erected on the Dana at the top of Howard Street. Later it was purchased by Mr J.B. Minor, Mayor of Shrewsbury, in 1851 and presented to the Borough. It was placed at the top of the avenue looking down towards the river.

THE NEW LIME trees had all been planted by 1952 and now, at sixty years old, provide beautifully shaded walks on hot summer days. Central Avenue was renamed Gloucester Avenue in 1974 after the Duchess of Gloucester who attended the centenary of the Flower Show that year. Hercules' left arm has been restored and he has been given a fig leaf to preserve his dignity. He was moved to this site in 1881 when new gates were erected at the entrance to the Quarry and after a number of Victorian ladies had objected to his lack of dress!

THE DINGLE

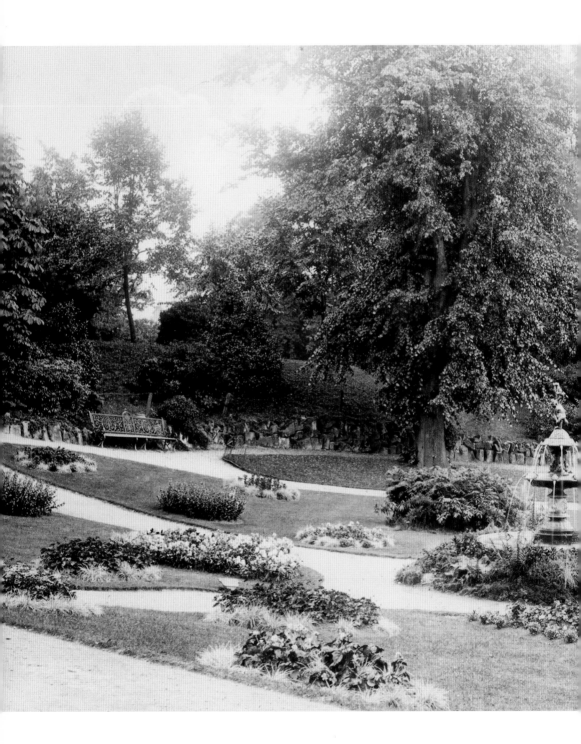

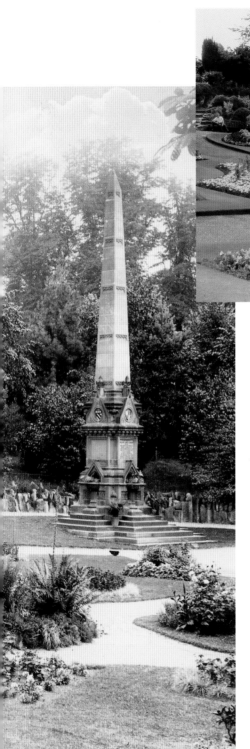

THE DINGLE, *c.* 1905. The Quarry takes its name from the stone extracted from the baths area and the Dingle, where it left this hollow. The pond was retained and it was formally laid out with paths, flower beds and shrubs in the 1870s. The ornamental fountain was a gift from the Independent Order of Oddfellows in 1889. The obelisk drinking fountain on the right commemorates William James Clement, a local surgeon, mayor and Member of Parliament for Shrewsbury. It is built out of Grinshill stone and was erected in the forecourt of the railway station in 1873. It was moved to this site in about 1899 when the forecourt at the station was being excavated.

THE CLEMENT MEMORIAL remained in the Dingle until 1939 when it was moved to the Greyfriars end of the Quarry. There it languished for years, overgrown with trees and bushes, but recently these have been cut back and the monument restored to its former glory. The top of the fountain was once surmounted by a young boy entwined by a snake. Unfortunately this was stolen and a poor modern replacement has been substituted for it. In 1946 television personality Percy Thrower became the Park's Superintendent. Under his expert supervision the Dingle was modernised and enhanced, a process that still continues under different leadership, making it a tranquil retreat to sit and relax.

KINGSLAND BRIDGE

THE KINGSLAND BRIDGE, *c.* 1895. The Kingsland Bridge Company was set up in 1872. The bridge is an iron structure resting on stone piers and has a single span of 212ft. It was constructed by the Cleveland Bridge and Engineering Company of Darlington and cost about £11,156. It was completed by 1881 but was not opened to traffic until Sunday 28 July 1882, which coincided with the opening of the new Shrewsbury School. The buildings under the bridge on the opposite side of the river are the malt houses belonging to Trouncer's Brewery in Longden Coleham. The boats for hire belong to Richard Ellis who had a boatyard up the Rea Brook in Old Coleham.

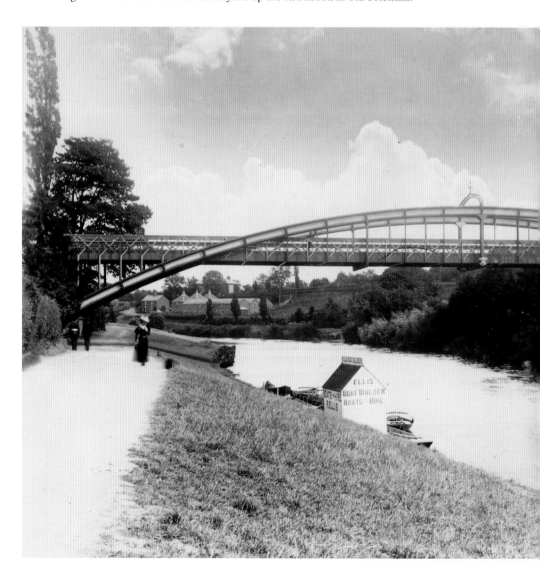

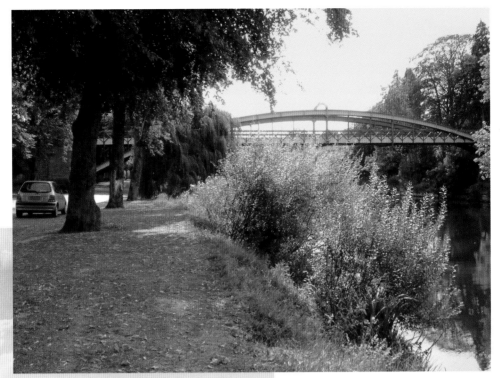

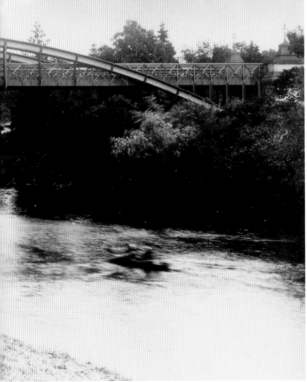

THE MODERN VIEW is now obscured by trees and bushes. The three larger trees are limes and were planted with others in an avenue that follows the river down to Greyfriars. The towpath was also widened and named Victoria Avenue, both to commemorate Queen Victoria's Diamond Jubilee. The bridge is a toll bridge and is known locally as the 'Penny Bridge' as that was the amount pedestrians had to pay to cross over. Until the flood defences were built in 2003 the bridge was the only dry route into the centre of Shrewsbury.

COOPER'S BOATS

COOPER'S BOATS, *c.* 1933. This business was established by Richard Ellis in 1859 and flourished for over a hundred years. It was taken over by George Cooper in 1906 along with a boat builder's yard in Old Coleham. In the 1920s a fleet of punts, canoes, pleasure, racing and fishing boats could all be hired by the hour from the landing stage on the Quarry side of the river. Cooper also owned two motor launches, the *Shropshire Lad* on the right and the *County Belle* on the left, which could take large parties on a cruise from 3.00 p.m. during the summer season. George Cooper is standing on the left of the pontoon while his assistant Arthur Bates is to the right.

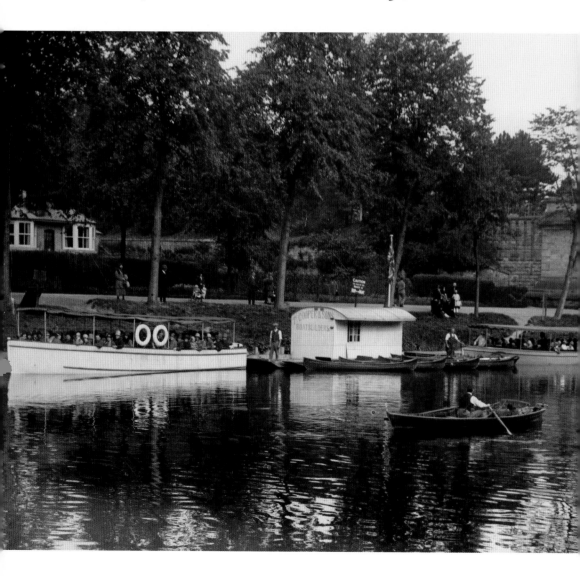

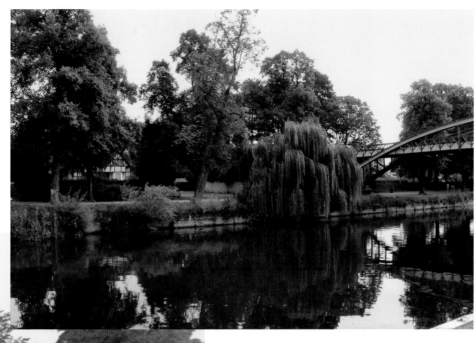

DURING THE WINTER the boat house and boats were taken down to the yard in Old Coleham to be cleaned and repaired for the next season. When trade declined in the early 1960s the *County Belle* went to Chester to take passengers on the Dee while the *Shropshire Lad* went to Worcester, lower down the Severn. Note the cottage on the bank behind the *County Belle*. It was once a one-bayed summer house with a garden running down to the towpath. By 1933 it had been extended by another bay and in recent years it has been given another storey and extended at the rear.

THE SEVERN

THE SEVERN FROM GREYFRIARS BRIDGE, August 1956. Scouts paddle downstream towards the
basin, the widest section of the Severn around Shrewsbury, where the Rea Brook joins the river
on the right. The buildings in the background are on Coleham Head, which was once an island,
when another arm of the Rea Brook flowed to the rear and entered the Severn close to the Abbey
Gardens. The white building just below the Abbey tower is Severn Villa. The frontage was rebuilt
in 1901 and it was once occupied by J.R. Morris, the proprietor of the *Shrewsbury Circular* that was
printed in the building to the right. Note the houses on the left that were susceptible to flooding and
the large number of swans on the right.

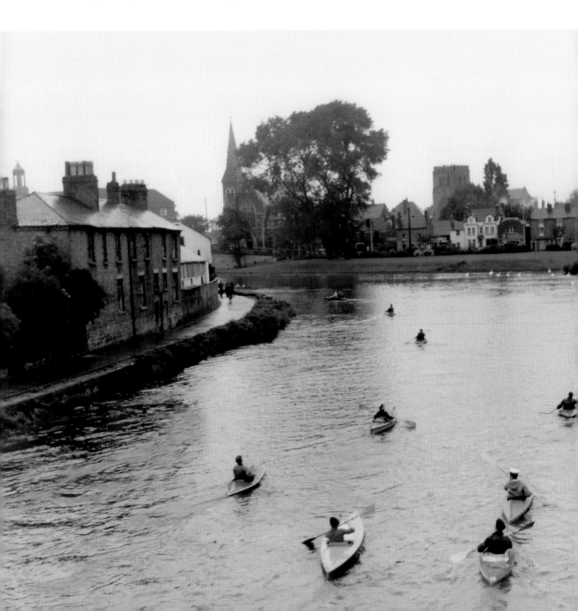

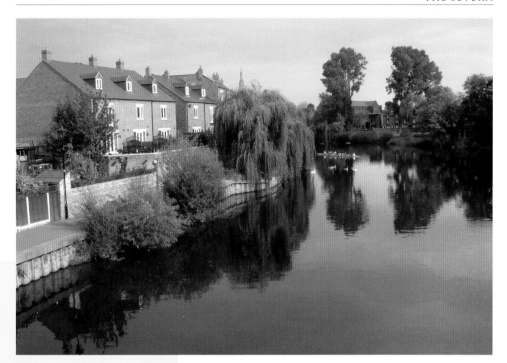

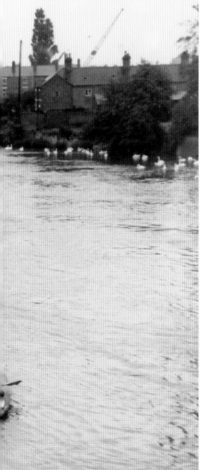

THIS TRANQUIL SCENE shows an eight from Pengwern Boat Club in mid-stream. Modern houses behind flood defences have replaced the old buildings on the left. Severn Villa has also been demolished to make way for a new gyratory road. Before demolition it was being used by the Archaeology Department of Birmingham University who were exploring parts of the monastic remains near the abbey. The Circular office has also been removed and replaced by a futuristic building by F.C. Manser & Sons, who are antique dealers.

THE ENGLISH BRIDGE

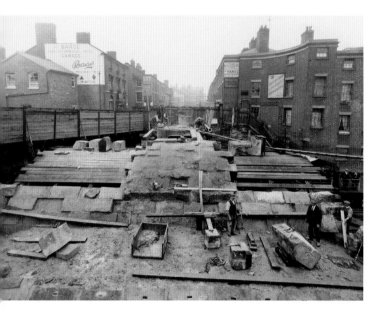

THE ENGLISH BRIDGE, *c.* 1926. Work is well underway in the widening and the rebuilding of the bridge, which took place between 21 August 1925 and 16 September 1927. The photographer is looking back towards town with the temporary road bridge on the left. The Barge Hotel was first recorded in the eighteenth century and rebuilt twice. It closed in the 1950s and was demolished to make way for a garage. The building on the right is part of English Bridge Court; note the advert for Arthur Charles' piano shop that stood in Mardol opposite the Empire cinema.

DURING THE ALTERATIONS to the bridge, the frontage of English Bridge Court was taken down and rebuilt several feet further back, bringing it level with the curve and losing the section that supported the piano advert. The removal of the Barge Hotel opens up a nice view of the side elevation of the building behind. The advert for cycles and motorcycles can also be seen on the old photograph when the building was occupied by T.E. Jones. The garage that once occupied the site of the hotel has also been removed to give access to a new housing complex.

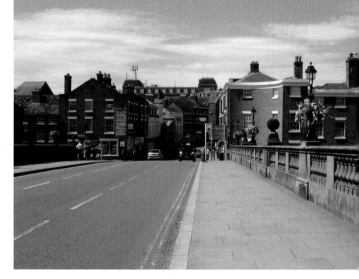

THE SALOP INFIRMARY

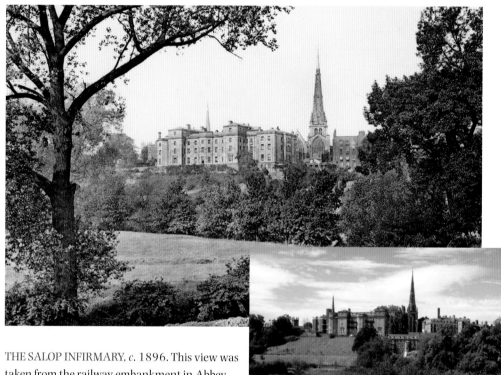

THE SALOP INFIRMARY, *c*. 1896. This view was taken from the railway embankment in Abbey Foregate. The open land is the Gay Meadow to where Shrewsbury Town FC moved in 1910 and just beyond the trees is the river. The first infirmary was opened on 25 April 1847 and was reported to be only the fifth in operation at that time. This building was erected on the same site and opened in September 1830 at a cost of £16,000. On the right is Stone House which was erected on the old town wall. It was built in the seventeenth century by Humphrey Lea of Langley and greatly altered in the eighteenth century. A great deal of the east end of St Mary's Church is revealed between the buildings. Note the top of the spire which was rebuilt after it was blown down in a gale on 11 February 1894.

THE NEW VIEW was taken slightly to the left of the old one, owing to the amount of undergrowth. The hospital was given the title 'Royal' in July 1914 by King George V. It closed in November 1977 when all medical facilities moved to Copthorne and was converted into shops and apartments called the Parade. Stone House was removed in 1908 to make way for a new nurses' home that was formally opened on 10 November 1910. After the hospital moved the building remained empty for a number of years but has now been converted into apartments. The football ground was moved in 2007 and the site is about to be redeveloped.

ABBEY FOREGATE

ABBEY FOREGATE, 5 June 1932.
Reconstruction of the railway bridge that takes
trains over the main road and off towards
Hereford and Wales is being carried out on a
Sunday when traffic was at a minimum. The
small wooden shops on the right were occupied
by Alfred Brayley, a cycle agent; Evan Roberts
a boot repairer, and Annie Iles a newsagent
and tobacconist. On the extreme right is part
of the Bull Inn, recorded from the eighteenth
century through to 1937. For many years it
was the home of the Woodnorth family who
were greatly involved with the Abbey Church.
The large three-storey house on the left with
the impressive pediment once belonged to the
Railway.

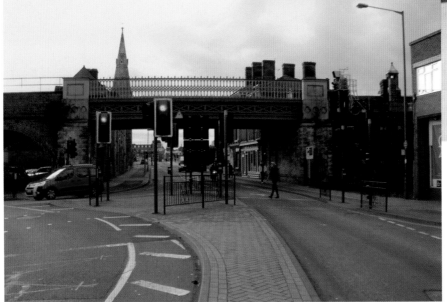

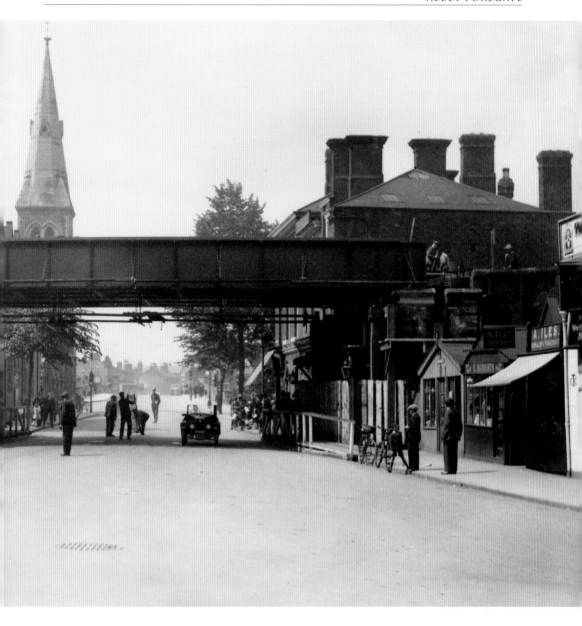

THE BRIDGE STILL takes rail traffic over the main road and looks quite smart painted red and green. The shops on the right have been demolished and the site is about to be redeveloped. The building occupied by the Bull Inn was demolished in the early 1960s and part of the site was occupied by a new Lloyd's Bank that was built several feet above the flood line. The house on the left was demolished to make way for the new gyratory road system that was opened in July 1991. At first it caused local drivers some confusion, with the *Chronicle* commenting, 'Befuddled drivers are causing chaos on Shrewsbury's latest traffic system – just hours after it was officially opened.'

ABBEY
STATION

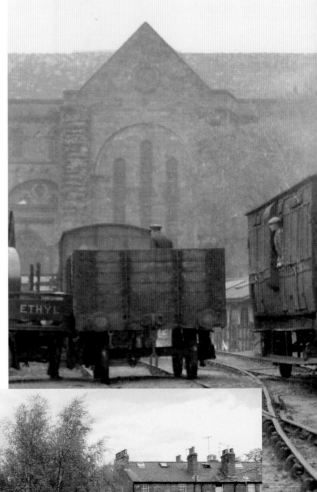

THE ABBEY STATION, *c.* 1930.
The Potteries, Shrewsbury & North
Wales Railway was opened in 1866.
The line thrived in the early years but
by 1880 profits had dropped, and it
closed in 1882. The line was reopened
by Colonel Stephens and renamed
the Shropshire & Montgomeryshire
Railway. On 1 June 1941 the section
from Shrewsbury to Llanymynech
was requisitioned by the military to
serve the Central Ammunition Depot
at Nesscliffe. In the background is the
south side of the Abbey Church and
the chancel rebuilt at the end of the
nineteenth century.

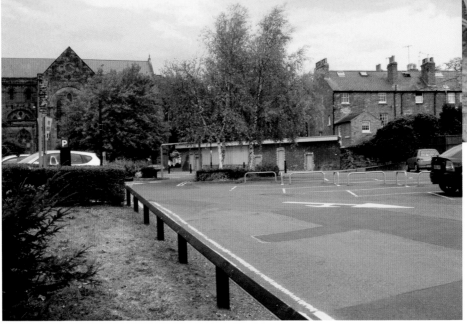

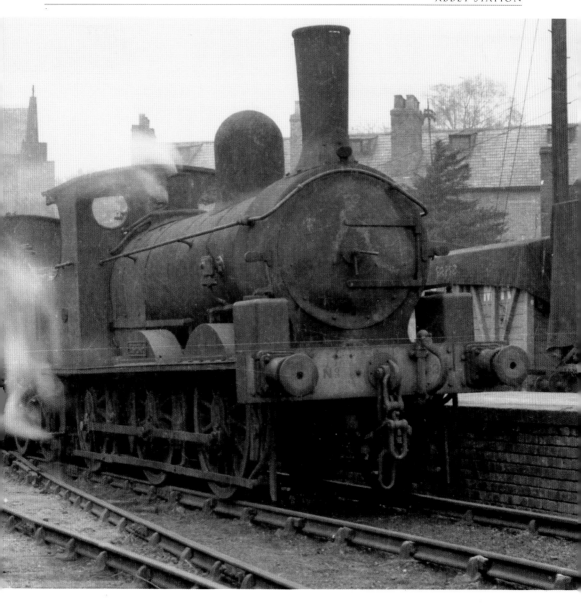

THE LINE CONTINUED TO FUNCTION AFTER THE WAR but only to the stone quarry at Criggion. Freight services, apart from the removal of stone, finished in May 1949 and the line officially closed in February 1960, although a special train for rail enthusiasts ran a month later. The entire track was lifted in 1962 apart from a small section to an oil depot in Abbey Foregate. After the depot closed in 1988 the final length of track was removed in 1990. Although transformed into a car park the station building and one platform remain. The building fell into dereliction and was targeted by squatters but recently it has been completely overhauled and it is hoped that it will house a small museum on the line's history and act as a tourist centre for this side of town.

ABBEY FOREGATE

ABBEY FOREGATE, *c.* 1945. This block of early nineteenth-century cottages were known as Heath's Houses. They were five substantial dwellings on two floors with dormer windows in the attic and a large cellarage. Just below is a newsagent's shop run by Percy Leah until the Second World War and then by Fred Jones. On the eave of the building were the initials R and E and a date of 1731. The upstairs windows were framed by attractive plaster mouldings and surmounted with a stone fleur-de-lys.

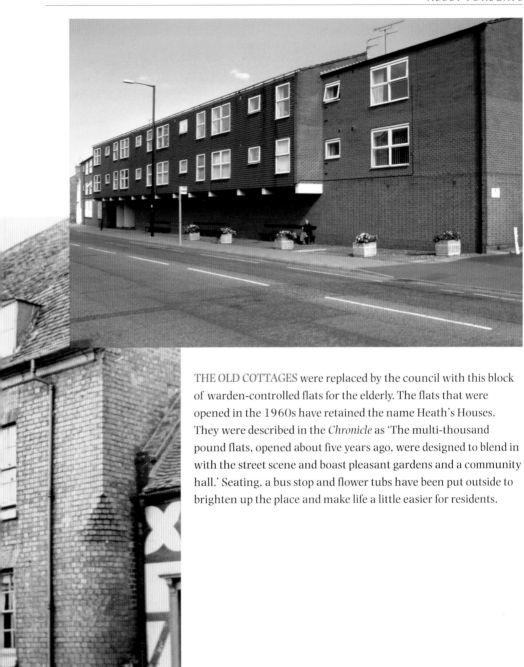

THE OLD COTTAGES were replaced by the council with this block
of warden-controlled flats for the elderly. The flats that were
opened in the 1960s have retained the name Heath's Houses.
They were described in the *Chronicle* as 'The multi-thousand
pound flats, opened about five years ago, were designed to blend in
with the street scene and boast pleasant gardens and a community
hall.' Seating, a bus stop and flower tubs have been put outside to
brighten up the place and make life a little easier for residents.

LONGDEN COLEHAM

LONGDEN COLEHAM, *c.* 1960.
The photographer is looking towards Old
Coleham and the Seven Stars. The row of
cottages on the right is typical of many houses
built in the suburbs during the nineteenth
century. The house at the junction of Moreton
Crescent was a fish and chip shop run by the
Phillips family. It had once been a working
men's club known as Cocoa House, an
alcohol-free environment to counter the many
evils of public houses in the area. On the left
is the sign for the Drill Hall, which in 1960
was the Headquarters of the 4th Battalion the
King's Shropshire Light Infantry (TA) and No. 8
(Shrewsbury) Shropshire Army Cadet Force.

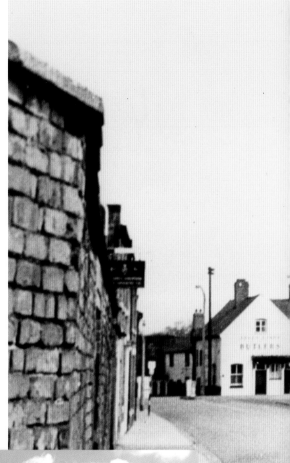

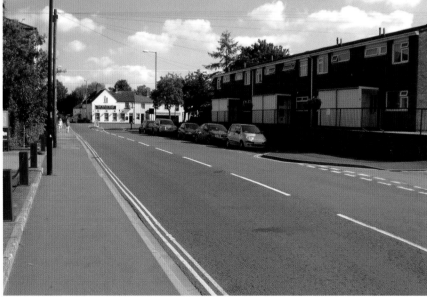

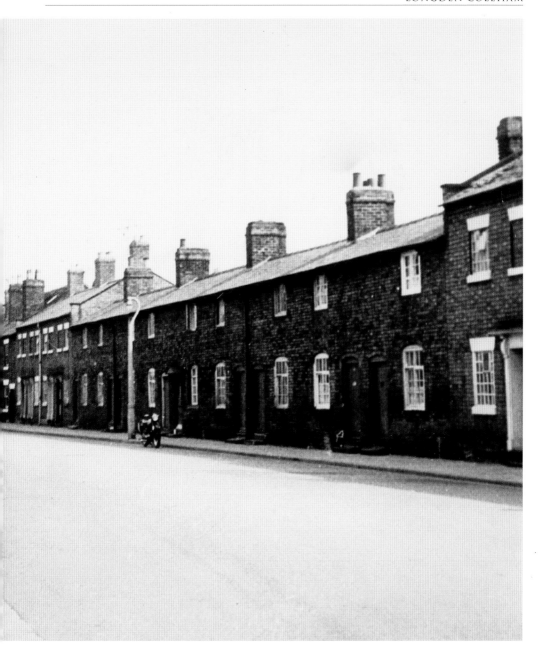

THE SCENE HAS changed quite dramatically and only the Seven Stars is there to identify the view. The road is wider and has parking bays on one side. The cottages have been demolished and replaced by 1960s-style housing that has been built well above the floodplain. The site of the chip shop has been left open giving a much better view of the Seven Stars. The wall in front of the Drill Hall and the cottages beyond have also been removed giving a much more open aspect.

FRANKWELL

FRANKWELL, 23 JANUARY 1899. The photographer is looking towards Frankwell Quay during a flood that rose to 17ft 6in above normal, submerging many of the properties in the Little Boro under several feet of water. The building on the left with the ornate gas lamp is the Seven Stars, one of several public houses in the area. The shop next door with the barber's pole belonged to Johnny Hughes; reputedly Frankwell's first elected mayor. At the beginning of the twentieth century the hairdressing business was taken over by Teddy Millington who ran it for over fifty years. The ornate structure in the middle of the road is a cast-iron gentlemen's urinal known locally as the 'Frankwell Relief Centre'.

THE NEW THEATRE SEVERN now dominates the skyline, dwarfing the timber-framed houses. The three-storey building in the old view was demolished in the early 1950s and the Atlas Foundry situated at the rear has been redeveloped into the Guildhall. The Seven Stars closed in about 1910 and for many years it was Mrs Millington's wardrobe shop selling a variety of second-hand furniture. The building was demolished in 1959 to make way for a block of flats built on a site known as Natty Price's corner, commemorating another barber whose shop was there for over fifty years. The ornate gentleman's urinal has been replaced by traffic lights.

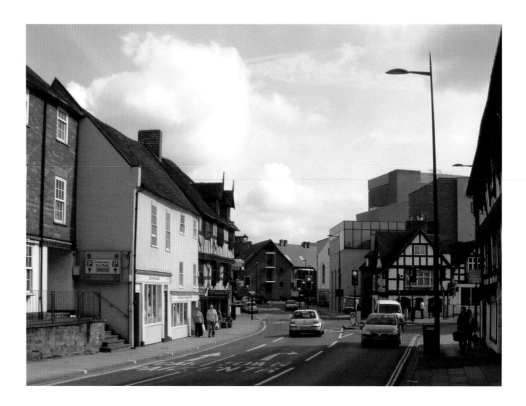

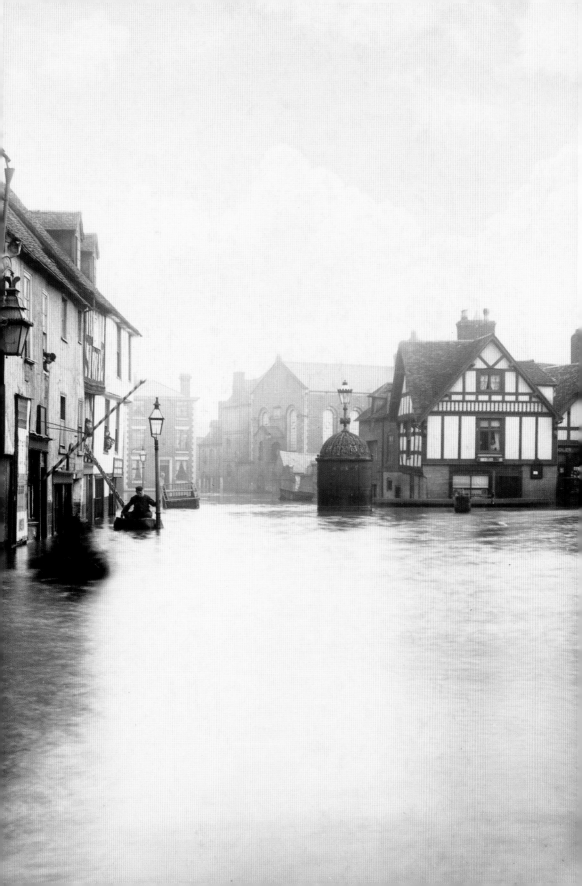

CASTLE FOREGATE

CASTLE FOREGATE, *c.* 1910. The Shrewsbury Industrial Co-operative Society, established in 1894, opened their first shop at 75 Castle Foregate. By 1914 they had shops in Longden Road, Frankwell, Whitehall Street and Hotspur Street and had opened offices and warehouses in Castle Foregate. Their goods were distributed around Shrewsbury by their fleet of horse-drawn and motorised vehicles. The large building with the clock tower is Corbett's Perseverance Ironworks that had been badly damaged by fire in November 1905. Just to the right is the Crown & Anchor Inn and just behind the first wagon on the right is the Bell Inn with its fine carved wood sign over the first-floor window.

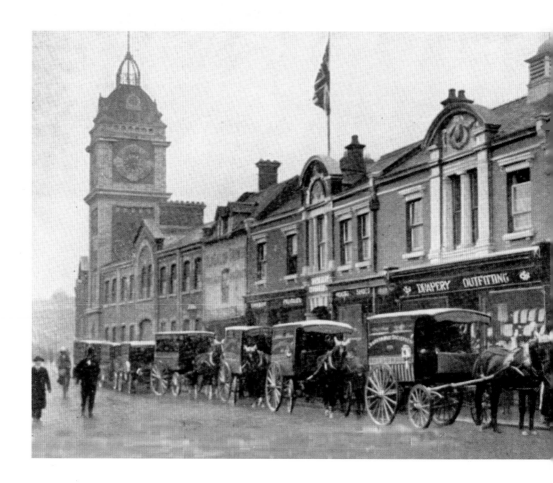

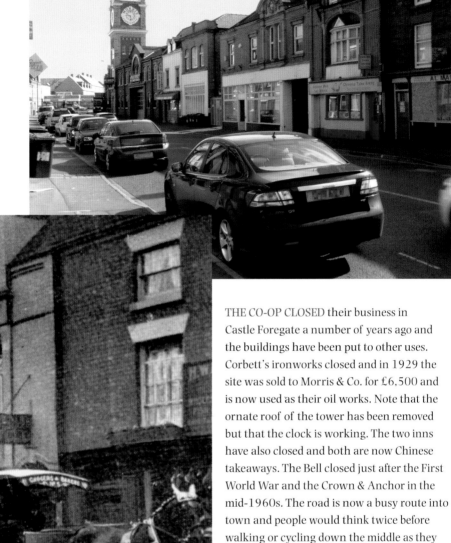

THE CO-OP CLOSED their business in Castle Foregate a number of years ago and the buildings have been put to other uses. Corbett's ironworks closed and in 1929 the site was sold to Morris & Co. for £6,500 and is now used as their oil works. Note that the ornate roof of the tower has been removed but that the clock is working. The two inns have also closed and both are now Chinese takeaways. The Bell closed just after the First World War and the Crown & Anchor in the mid-1960s. The road is now a busy route into town and people would think twice before walking or cycling down the middle as they did in the old view.

HEATHGATES

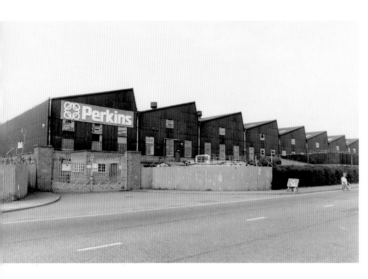

HEATHGATES, *c.* 1985. Early in 1915, the Glasgow firm of Alley & MacLellan bought 16 acres of land on the west side of the Whitchurch road to build their new factory. Work on the building began in March and by July of that year the first steam waggon had rolled off the assembly line and was ready for testing. In 1918, the factory became known as the Sentinel Waggon Works and traded under that name until 1956 when the factory was acquired by Rolls-Royce, mainly for the production of diesel engines. The factory was sold to Perkins in 1985.

THE FACTORY CLOSED in about 1990 when production was moved to a site at the rear on the other side of the railway line. This area was then redeveloped in about 1992 into a large Morrisons supermarket and petrol station. The roof of the supermarket is just visible above the landscaped embankment and the petrol station is on the right.

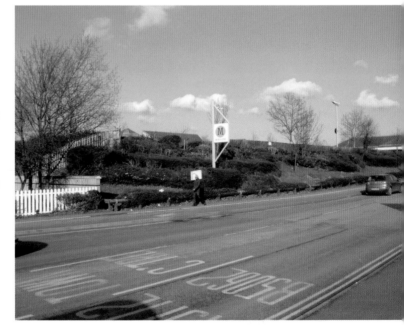

HARLESCOTT

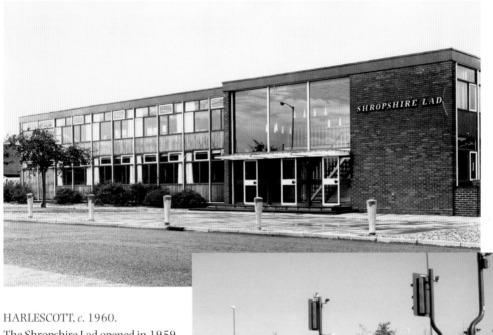

HARLESCOTT, *c.* 1960.
The Shropshire Lad opened in 1959, which coincided with the second phase of the cattle market's move from the town centre to this site. The bar and restaurant was housed in a typical 1960s building, whose architecture was described as being 'in the cubist style'. On the ground floor was the 56ft long bar, which was fully equipped and could cater for seventy people sitting and about 200 standing. The restaurant on the second floor could cater for 132 people in tables of four and was open early on market days to provide a good English breakfast for hungry farmers. The facility was also a popular venue for dinner dances and wedding receptions.

THE CATTLE MARKET operated for less than fifty years and was moved again at the beginning of the twenty-first century to a new site at Battlefield. The move saw the closure of the Shropshire Lad which was demolished with the rest of the market site. The area was then developed into a Tesco Plus supermarket and petrol station. Tesco opened their first supermarket in the centre of Shrewsbury on 21 September 1965 and then moved to another site in Harlescott before opening this store. The colourful sheep is one of several mounted on a monument to commemorate the site's association with the livestock market.

ACKNOWLEDGEMENTS

I am indebted to all the people who have given or loaned me photographs of Shrewsbury over the last forty years. Without their kindness and generosity none of my books would have been possible. I am also grateful to the Shropshire Records and Research Centre for all their help and for their unbounded patience. I would also like to acknowledge the work of Toby Neal of the *Shropshire Star* who has done so much to uncover the stories behind old photographs of the county and for writing so many interesting articles. My thanks also go to my wife Wendy for all her help and encouragement and for proof reading the text.

BIBLIOGRAPHY

Forrest, H.E., *The Old Houses of Shrewsbury*, Wilding & Son, 1920.
Hobbs, J.L., *Shrewsbury Street Names*, Wilding & Son, 1954.
Kelly's Directories of Shropshire, various dates.
Lloyd, L.C., *The Inns of Shrewsbury*, reprint Shropshire Libraries, 1976.
Moran, M., *Vernacular Buildings of Shropshire*, Logaston Press, 2003.
Morriss, R.K., *The Buildings of Shrewsbury*, Sutton, 1993.
Pidgeon, H., *Memorials of Shrewsbury*, J.H. Leeke, 1851.
Rees, H., *Tour of Shrewsbury Sights*, Howell Rees, 2000.
Shrewsbury Chronicle, various dates.
Trinder, B. (ed.), *Victorian Shrewsbury*, Shropshire Libraries, 1984.
Trinder, B., *Beyond the Bridges*, Phillimore & Co. Ltd, 2006.
Ward, A.W., *The Bridges of Shrewsbury*, Wilding & Son, 1935.
Ward, A.W., *Shrewsbury, A Rich Heritage*, Wilding & Son, 1946.
Wilding Directories, various dates.